AMERICAN ARTISTS
IN PHOTOGRAPHIC PORTRAITS
FROM THE PETER A. JULEY & SON COLLECTION

National Museum of American Art
Smithsonian Institution

Compiled and written by
JOAN STAHL

NATIONAL MUSEUM OF AMERICAN ART, SMITHSONIAN INSTITUTION
IN ASSOCIATION WITH
DOVER PUBLICATIONS, INC., NEW YORK

ACKNOWLEDGMENTS

Several colleagues at the National Museum of American Art have assisted me on this project. My appreciation is extended to Elizabeth Broun, Director; Steve Dietz, Publications; Rachel Allen, Research and Scholars Center; Pat Lynagh, Library; Karen Cassedy, Computer Resources; John Jones, Jennifer Heffelfinger, José Castro, Guy Loraine and Andrea Nunes, Juley Printing Project. Museum editor Melissa Hirsch and my husband, Barry Stahl, have been particularly supportive and helpful.

J. S.

COPYRIGHT

First published in the United States of America by Dover Publications, Inc., in association with the National Museum of American Art, Smithsonian Institution, Washington, D.C. 20560.

© 1995 National Museum of American Art, Smithsonian Institution. All rights reserved. No part of the text of this book may be reproduced in any form without the written permission of the National Museum of American Art.

DOVER *Pictorial Archive* SERIES

The National Museum of American Art, Smithsonian Institution, is dedicated to the preservation, exhibition and study of visual arts in America. The museum, whose publications program also includes the scholarly journal *American Art,* has extensive research resources: the databases of the Inventories of American Painting and Sculpture, several image archives and a variety of fellowships for scholars. The Renwick Gallery, one of the nation's premier craft museums, is a part of NMAA. For more information or a catalogue of publications, write: Office of Publications, National Museum of American Art, Smithsonian Institution, Washington, D.C. 20560. NMAA also maintains a gopher site at nmaa-ryder.si.edu and a World Wide Web site at http://www.nmaa.si.edu. For further information, send e-mail to NMAA.NMAAInfo @ic.si.edu.

LIBRARY OF CONGRESS CATALOGING-IN-PUBLICATION DATA

National Museum of American Art (U.S.)
 American artists in photographic portraits : from the Peter A. Juley & Son collection, National Museum of American Art, Smithsonian Institution / compiled and written by Joan Stahl.
 p. cm. — (Pictorial archive)
 ISBN 0-486-28659-2 (pbk.)
 1. Artists—United States—Portraits. 2. Portrait photography—United States. 3. Juley, Peter A., 1862–1937. 4. Juley, Paul, 1890–1975. I. Stahl, Joan. II. Title. III. Series.
TR681.A7N34 1995
779′.2′0922—dc20 95-3974
 CIP

Manufactured in the United States of America
Dover Publications, Inc., 31 East 2nd Street, Mineola, N.Y. 11501

INTRODUCTION

PETER A. JULEY (1862–1937) was born in Alf, a small German town on the Mosel River. While research has uncovered only limited information about Juley's life in Germany or his early years in this country, it is known that he immigrated to the United States in 1888 and opened a barbershop/photo studio in Cold Spring, New York, in 1896.

Juley worked as a photographer for *Harper's Weekly* from 1901 to 1906 but quickly developed a specialty that would define his life's work and that of his son, Paul (1890–1975): photographing artists, the overwhelming majority of whom were American, and their works. The Juleys dominated this sphere of their profession and gained reputations as sensitive, artistic, sympathetic and responsible professionals with singular powers of observation and expert technical skills. Their clients included artists, collectors, museums, galleries and art schools, and a listing of them reads like a "Who's Who of Art."

Peter first set up shop in New York City sometime shortly after 1906, and Paul joined the enterprise when he became an adult. Aided by their able assistant Carlton Thorpe, an integral part of the operation for more than 50 years, the Juleys saw their business flourish. They photographed the artists and activities associated with both the National Academy of Design and the Art Students League, as well as other major art organizations. That their interest in art extended beyond the commercial was certainly a key to their

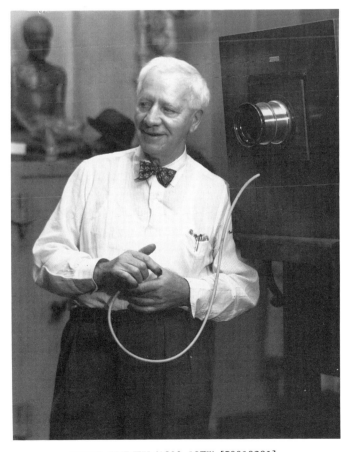

PETER A. JULEY (1862–1937) [J0010346] **PAUL JULEY** (1890–1975) [J0010301]

success; active and esteemed members of the Salmagundi Club, a social organization that promotes discourse between artists and those interested in the arts, they were on a first-name basis with many artists. When the New York City urbanites migrated to summer art colonies in Woodstock, New York, or Old Lyme, Connecticut, the Juleys were also there.

This collection of their work, now owned by the National Museum of American Art, Smithsonian Institution, numbers approximately 127,000 photographs, which capture the artworks of an estimated 11,000 artists. The portraits of artists shown here are a small, but particularly rich, component of the whole. The Juleys took special pride in these portraits and lined the walls of their studio with the likenesses of their clients. The selections in this volume are a sampling, including the well-known, as well as the once-known and ready-to-be-rediscovered.

The portraits in this compilation were selected as the best examples of the range in the Juleys' work, with preference given to portraits that either captured signature characteristics or revealed surprising qualities of the artist. Like other commercial photographers, the Juleys sometimes purchased the negatives of colleagues who died or went out of business. A few of the portraits included in this volume are likely the work of other photographers.

For many years the Juley studio was located a few doors away from the Art Students League and across the street from Carnegie Hall, the site of many artists' studios. It is not surprising then that the collection is particularly strong in its representation of New York City–based artists, many of whom were active in the artists' groups with which the Juleys were also affiliated. The Juleys' business endured for 80 years until Paul's death in 1975. This collection is both an outstanding legacy of the life work of a father and son and a prodigious record of American art for the first three quarters of this century.

The Selected List enumerates many more artist portraits that could not be included in a volume of this size. Interested individuals may purchase publication-quality prints of any photograph in the collection; the eight-digit serial number in brackets at the end of each caption is its identification number. Inquiries about the purchase of prints or the Peter A. Juley & Son Collection are welcome and may be directed to the Slide and Photo Archives—Room 331, Research and Scholars Center, National Museum of American Art, Smithsonian Institution, Washington, D.C. 20560; phone (202) 357-1348.

PETER JULEY'S first studio in Cold Spring, New York [J0010281]

A SELECTED LIST OF OTHER PORTRAITS
IN THE PETER A. JULEY & SON COLLECTION

Abrams, Lucien
Adams, Herbert
Adams, Kenneth M.
Aiken, Charles Avery
Alajalov, Constantin
Albee, Percy
Allen, Charles Curtis
Allen, Junius
Amateis, Edmond
Anderson, Karl
Anderson, Ruth A.
Anderson, Victor
Angela, Emilio
Asplund, Tore

Bach, Florence Julia
Baker, Bryant
Baker, Lamar
Ball, Linn
Ball, Thomas Watson
Barbarossa, Theodore
Barnes, Ernest Harrison
Barnett, Herbert
Baskerville, Charles
Bassford, Wallace
Batchelder, John
Baumgartner, Warren
Beach, Chester
Beard, Daniel Carter
Beck, Dunbar
Benney, Robert
Bensing, Frank
Berge, Edward
Berninghaus, Oscar Edmund
Betts, Louis
Biggs, Walter
Bitter, Karl
Blackstone, Harriet
Block, Adolph
Bohm, Max
Bohnert, Herbert
Bohnert, Rosetta
Bollendonk, Walter
Boog, Carle Michel
Booth, Cameron
Boronda, Beonne
Boronda, Lester
Bosa, Louis
Botkin, Henry Albert
Boulton, Joseph
Bradford, Francis Scott
Brecher, Samuel
Breckenridge, Hugh
Breinin, Raymond

Brenner, Victor
Brightwell, Walter
Brindesi, Olympio
Brinley, Daniel Putnam
Brockman, Ann
Browne, Belmore
Bruestle, George
Buller, Audrey
Burlin, Harry Paul
Burroughs, Bryson

Calfee, William H.
Campbell, Alice
Castellón, Federico
Cecere, Gaetano
Chadwick, William
Chaffee, Oliver
Chambellan, Rene
Chanler, Robert
Chapin, James
Chapman, Charles
Chatterton, C. K.
Cheney, Russell
Chi, Chen
Child, Edwin Burrage
Choate, Nathaniel
Ciampaglia, Carlo
Cikovsky, Nicolai
Cimiotti, Gustave
Cirino, Antonio
Clark, Eliot
Clark, Walter
Clayton, Alexander
Clime, Winfield Scott
Cochran, Gifford
Coes, Kent Day
Cole, Alphaeus
Coletti, Joseph
Cook, Peter
Coolidge, Mountfort
Cooper, Margaret
Cooper, Mario
Cox, Allyn
Crandall, Bradshaw
Crisp, Arthur

Dabo, Leon
D'Alessio, Gregory
De Coux, Janet
De Francisci, Anthony
De Haven, Franklin
Delbos, Julius
De Lue, Donald
De Maine, Harry

De Marco, Jean
Derujinsky, Gleb
Dessar, Louis Paul
Detwiller, Frederick K.
Dickinson, Preston
Dixon, Maynard
Donahue, William Howard
Draper, William
Duncan, Walter Jack
Dunn, Harvey T.
Dunsmore, John Ward
Dunwiddie, Charlotte
Du Pen, Everett George
Du Pré, Grace Annette
Durlacher, Ruth

Ebert, Charles H.
Ederheimer, Richard
Edwards, George Wharton
Eliscu, Frank
Ellerhusen, Ulric H.
Engel, Michael, Jr.
Enneking, Joseph Eliot
Etnier, Stephen Morgan
Evans, John W.
Evans, Rudolph

Fabri, Ralph
Faggi, Alfeo
Fairbanks, Avard
Farndon, Walter
Farnham, Sally
Farnsworth, Jerry
Faulkner, Barry
Finck, Furman
Fink, Denman
Fiske, Gertrude
Fitzgerald, Edmond
Fjelde, Paul
Fleri, Joseph
Flood, Mary Emma
Folinsbee, John
Foote, Will Howe
Fraser, Laura Gardin
Fredericks, Marshall
Friedlander, Leo
Friend, David
Frishmuth, Harriet
Fry, Sherry
Fuchs, Emil

Gage, Merrell
Gahman, Floyd
Gallatin, Albert Eugene

Gambee, Martin
Ganso, Emil
Gassner, Mordi
Geissbuhler, Arnold
Gilbert, Arthur Hill
Goltz, Walter
Gottlieb, Harry
Graves, Abbott
Gray, Mary
Greacen, Nan
Greene, Daniel
Greene, Stephen
Greenwood, Marion
Gregory, Angela
Gregory, John
Grieve, Maurice
Grigor, Margaret
Grimes, Frances
Grinnell, G. Victor
Groll, Albert
Gross, Sidney
Guion, Molly
Gurr, Lena

Hale, Robert
Hamilton, Hildegard
Hansen, Armin
Hare, Channing
Hare, Jeannette
Hartley, Joan
Hartley, Rachel
Hartman, Rosella
Hawthorne, Marion Campbell
Heerman, Norbert
Heinz, Charles Lloyd
Hensche, Henry
Hensley, Jackson
Herter, Christine
Heustis, Louise Lyons
Heuston, George Franklin
Hildebrandt, Howard Logan
Hirsch, Stefan
Hoffman, Harry
Holberg, Richard
Hovannes, John
Hovell, Joseph
How, Kenneth
Howard, Cecil
Howard, Eloise
Hudson, Eric
Hughes, Daisy Marguerite
Humes, Ralph
Hunt, Lynn Bogue
Hutty, Alfred

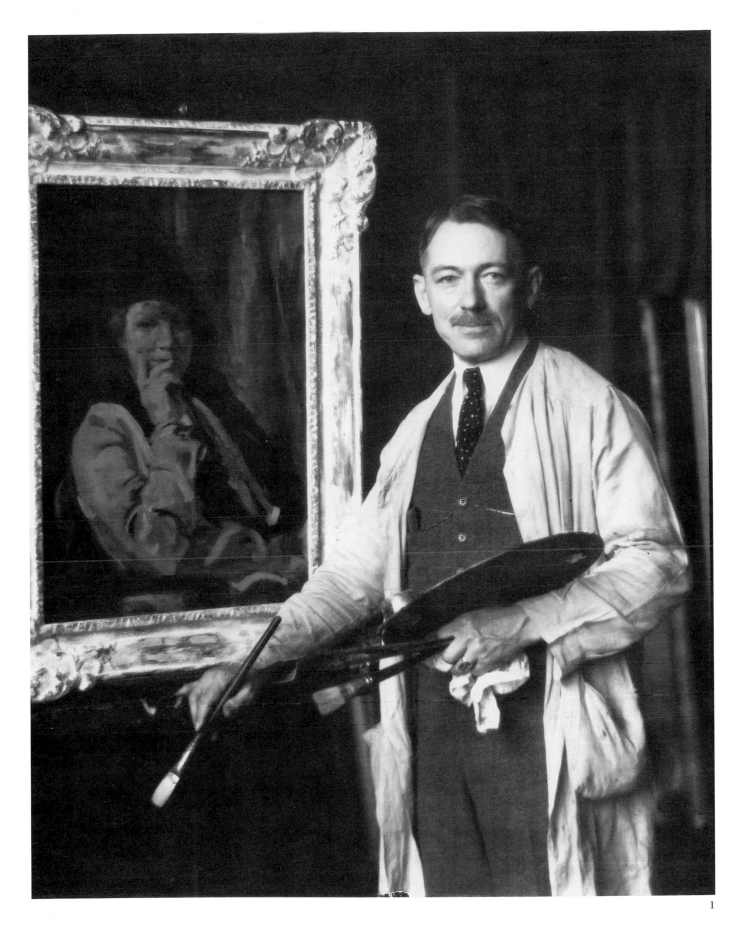

1. WAYMAN ADAMS (1883–1959), portrait painter, remembered for his candid portrayals of etcher Joseph Pennell, author Booth Tarkington and golfer Bobby Jones, among others. He also taught a popular summer portrait class in the Adirondack Mountains at Elizabethtown, N.Y. [J0080193]

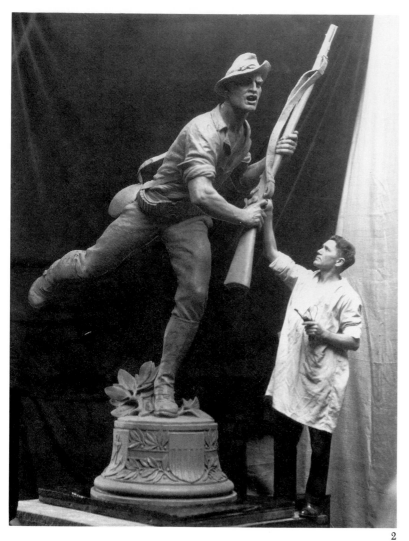

2

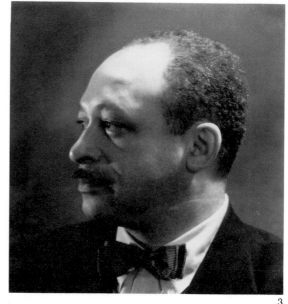

3

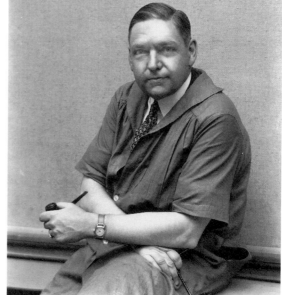

4

2. **ROBERT INGERSOLL AITKEN** (1878–1949), sculptor. Aitken was honored with awards from the National Academy of Design and the New York Architectural League, among other groups. The figure group *The Flame* (1911) and the bronze doors he executed for the John W. Gates mausoleum (Woodlawn Cemetery, N.Y.) are good examples of his work. [J0001185]

3. **CHARLES ALSTON** (1907–1977), painter, sculptor, muralist and educator. Trained in New York at the height of the Harlem Renaissance, Alston became an arts advocate. He was a member of the New York City Arts Commission as well as the National Council on the Arts. In 1950, he became the first African-American instructor at the Art Students League, where he taught for 25 years. [J0001167]

4. **JOHN TAYLOR ARMS** (1887–1953), graphic artist, first trained as an architect. He is best known for his etchings of medieval French architecture, which are characterized by attention to intricate detail. [J0001199]

5. **CLIFFORD W. ASHLEY** (1881–1947), painter, born in New Bedford, Mass. He was a pupil of illustrator Howard Pyle and author-illustrator of several whaling books. [J0001176]

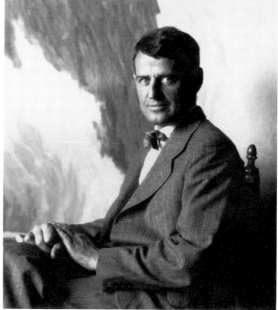

5

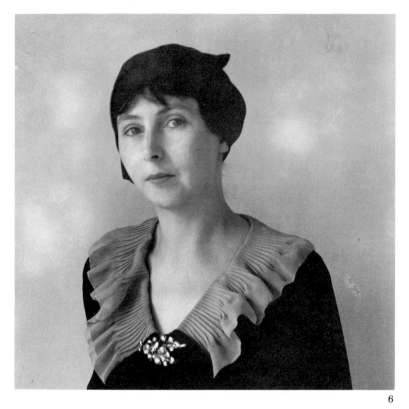

6. **PEGGY BACON** (1895–1987), painter, portrait painter, caricaturist, illustrator, lithographer, writer and art educator who studied with John Sloan and Kenneth Hayes Miller. Her sharp wit was evident in her contributions to the *New Yorker* and *Vanity Fair* as well as in the more than 60 books she illustrated, including several publications of her own short stories and poetry. [J0001287]

7. **GEORGE GREY BARNARD** (1863–1938), sculptor. One of the most original sculptors of his day, he gained prominence at the Paris Salon in 1894 with *Struggle of the Two Natures*. His vast collection of medieval sculpture eventually formed the core of the collection of the Cloisters in New York City. [J0001282]

8. **WILL BARNET** (born 1911), painter and printmaker, teacher at the Art Students League. Barnet's images of women and domestic scenes, distinctive in their emphasis on flat painting surfaces, are meditative in tone. [J0001263]

6

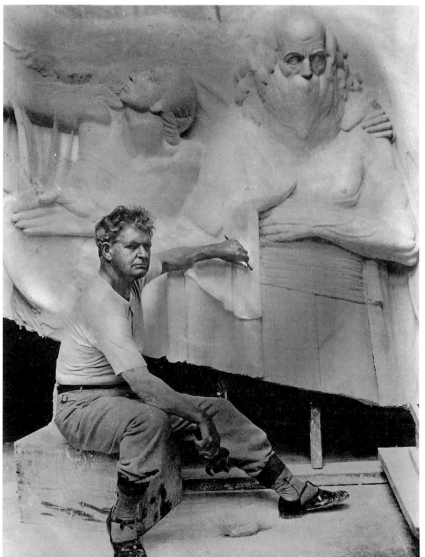

7

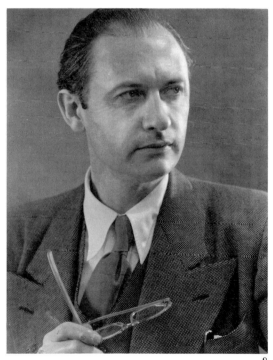

8

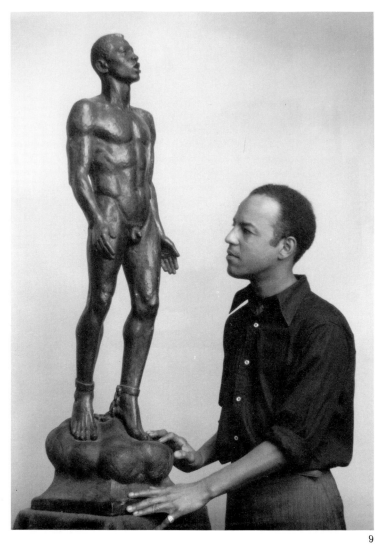

9

9. RICHMOND BARTHÉ (1901–1989), sculptor and painter. Barthé's forte was realistic sculptures of religious subjects, figures in African-American history, and stage and dance celebrities. [J0120650]

10. PAUL WAYLAND BARTLETT (1865–1925), sculptor. Son of the minor sculptor Truman Howe Bartlett, the artist trained in France with Emmanuel Frémiet and became an eminent Beaux Arts sculptor. Well-known examples of his work are the equestrian *Lafayette* (1899–1908), donated by the United States to France, and the pediment of the west wing of the U.S. Capitol. [J0056864]

11. KENNETH BATES (1895–1973), painter who exhibited at the Pennsylvania Academy of the Fine Arts and was active in the Mystic Connecticut Art Colony. [J0001266]

11

10

12. WILLIAM BAZIOTES (1912–1963), painter, a first-generation New York Abstract Expressionist. Marine life is suggested by the titles Baziotes selected for many of his paintings, which showed the Surrealist influences of Joan Miró and André Masson in the use of biomorphic shapes. The artist exhibited his paintings widely in national and international exhibitions. [J0001268]

13. GIFFORD BEAL (1879–1956), painter and etcher, an American Impressionist who studied with William Merritt Chase. He painted romantic scenes of New York City, the circus and New England landscapes. [J0001252]

14. HILDA BELCHER (1881–1963), portrait painter. Early in her career, Belcher distinguished herself in watercolor; however, it was for her later work in oils that she won awards. *Portrait by Night* (1931), a painting of a young woman, was awarded both the Thomas R. Proctor Prize by the National Academy of Design in 1931 and the Lippincott Prize by the Pennsylvania Academy of the Fine Arts in 1932. [J0001257]

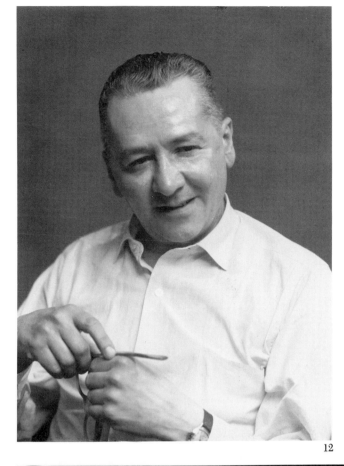

12

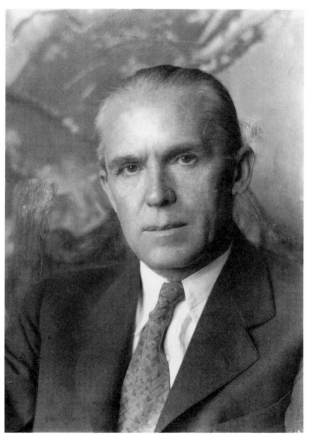

13

14

5

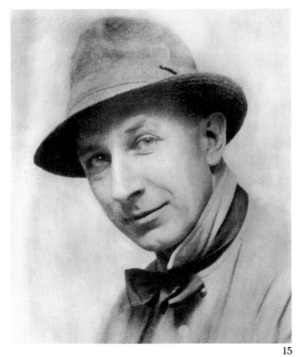

15

15. GEORGE BELLOWS (1882–1925), realist painter who moved from his hometown of Columbus, Ohio, to New York City, establishing himself as a painter of the bustling urban landscape. He was associated with The Eight and influenced by Robert Henri. [J0001238]

16. THOMAS HART BENTON (1889–1975), American scene painter who, along with John Steuart Curry and Grant Wood, was a leading regionalist painter of the 1930s. Well known for his murals and portraits depicting everyday life, particularly in the Midwest, Benton authored two autobiographies, *An Artist in America* (1937) and *An American in Art* (1969). [J0001205]

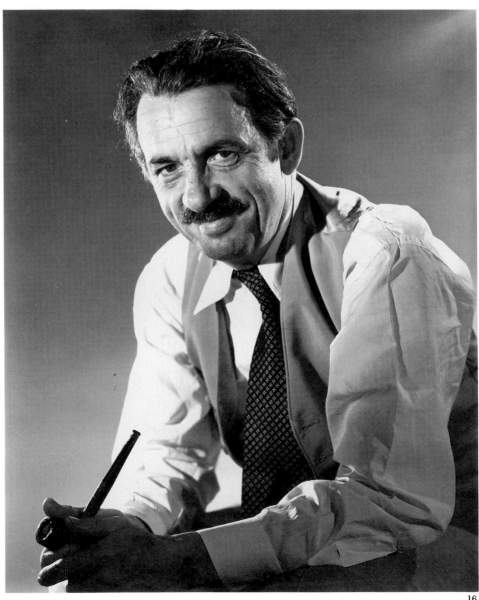

16

17. THERESA BERNSTEIN (born 1890), realist painter in the traditions of the Ashcan and New York Realism Schools, wife of William Meyerowitz. Her favorite themes included parades, beach scenes, music and the theater, as well as women at leisure and in the workplace. In the 1920s, her sensitive and sympathetic depictions of everyday life brought her critical acclaim that declined as she turned her attention to promoting her husband's work and as Abstract Expressionism gained momentum. [J0063639]

18. GEORGE BIDDLE (1885–1973), muralist and portrait painter instrumental in the development of Federal arts programs during the Depression. The influence of Diego Rivera is evident in his murals, the most famous being five fresco panels for the Department of Justice Building in Washington, D.C. [J0043766]

19. ISABEL BISHOP (1902–1988), painter and printmaker. Her preferred subjects were nudes, interiors and urban landscapes—often Union Square in New York City—inhabited by shoppers and working people. She was a member of the Fourteenth Street School of social realist painters, which included Kenneth Hayes Miller, Reginald Marsh, Morris Kantor and Moses and Raphael Soyer. [J0001217]

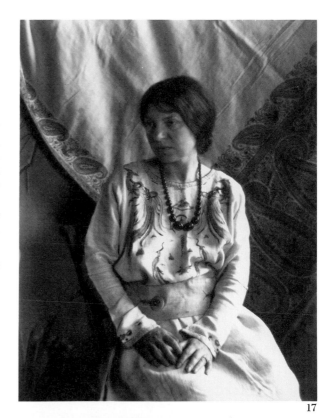

17

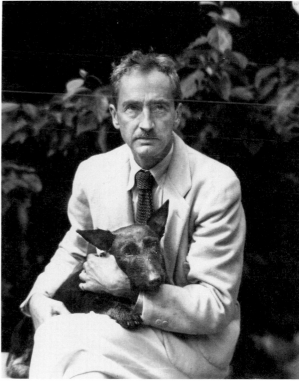

18

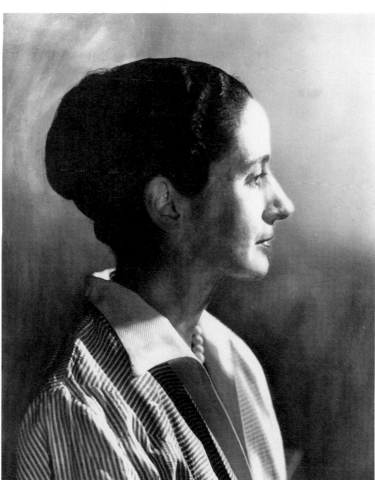

19

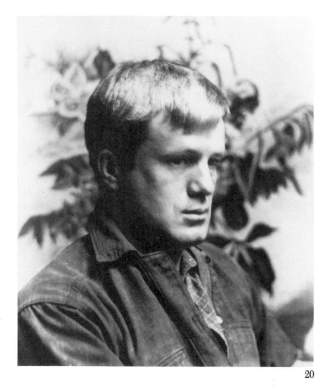

20. ARNOLD BLANCH (1896–1968), realist painter in the style of his teachers, Kenneth Hayes Miller, John Sloan and Robert Henri. An active member of the artists' colony in Woodstock, N.Y., he painted informal portraits and land-scapes. [J001216]

21. EDWIN HOWLAND BLASHFIELD (1848–1936), muralist. One of the most notable muralists of his day, he studied with the French academic painters Léon Bonnat and Jean-Léon Gérôme. His murals decorated high-profile public and commercial buildings, including the Library of Congress. [J0044087]

22. PETER BLUME (1906–1992), painter. A highly original artist whose imaginative juxtaposition of the surrealistic and everyday always evokes strong critical reactions. *Parade* (1930), for example, depicts a workman carrying medieval armor on a pole past a factory. He gained public attention in 1934 with *South of Scranton,* first-prize winner at the Carnegie International Exhibition. [J0001219]

20

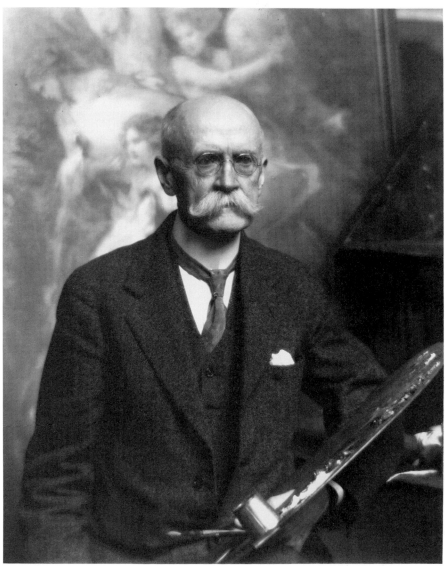

21

22

23

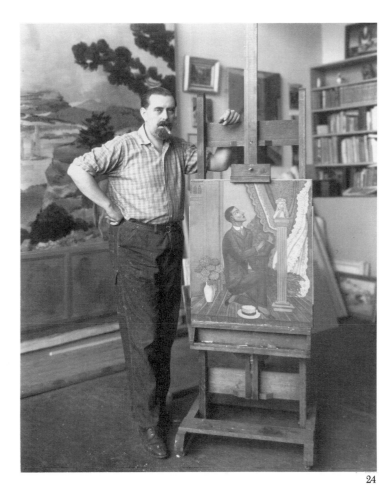

24

23. ERNEST BLUMENSCHEIN (1874–1960), painter and one of the founders of the Taos Society of Artists in Taos, N.M. For many years he divided his time between New York City—where he worked as an illustrator and taught at the Art Students League—and Taos, finally moving to the West in 1919. His landscapes often depicted Native American and Mexican-American subjects. [J0001214]

24. LOUIS BOUCHÉ (1896–1969), painter, muralist and teacher at the Art Students League and the National Academy of Design. In the 1920s he managed Wanamaker's Belmaison Galleries, the first modern art gallery in a department store in New York City. [J0001232]

25. ROBERT BRACKMAN (1898–1980), figure and portrait painter. He held portrait commissions from the du Ponts, Helen Morgan and the Lindberghs. His work characteristically combined still lifes with portraiture. [J0044995]

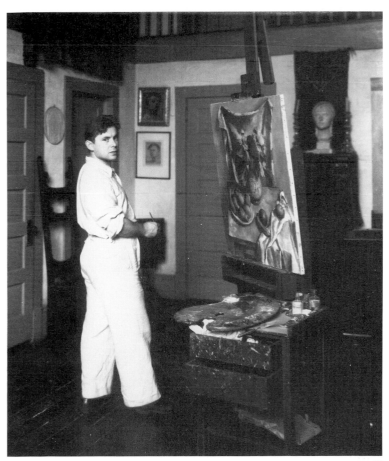

25

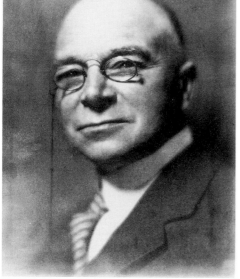

26

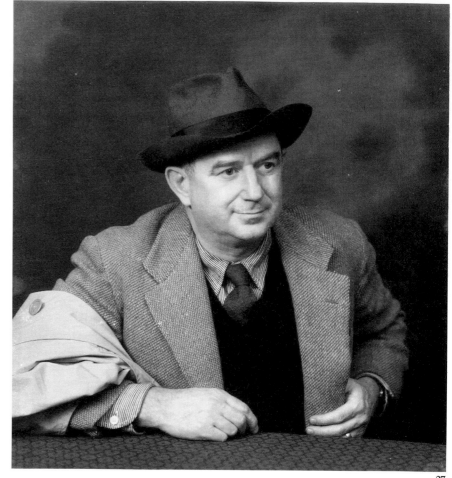

27

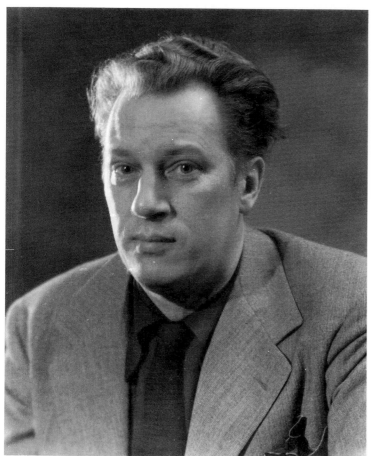

28

26. **GEORGE BRANT BRIDGMAN** (1864–1943), teacher who specialized in artistic anatomy at the Art Students League. *Bridgman's Life Drawing* and *Constructive Anatomy,* two of his contributions to the field, have gone through numerous printings and are standard texts for art students. [J0001308]

27. **ALEXANDER BROOK** (1898–1980), realist painter. His paintings, mostly of still lifes, landscapes and women, were very successful in his day. He won second prize to Picasso's first prize at the Carnegie Institute International Exhibition of Modern Painting in 1930. [J0001315]

28. **BYRON BROWNE** (1907–1961), modernist painter and one of the founders of American Abstract Artists, a New York City organization devoted to exhibiting abstract art. Browne specialized in still lifes in the style of Synthetic Cubism, influenced by his friends John Graham, Arshile Gorky and Willem de Kooning. [J0001290]

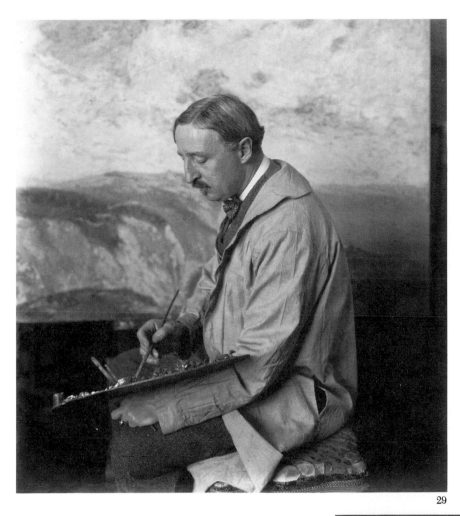

29

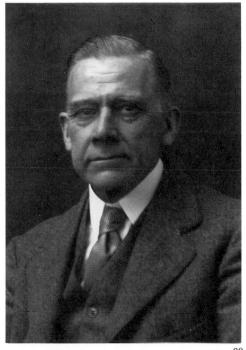

30

29. GEORGE ELMER BROWNE (1871–1946), landscape painter whose training included study at the Académie Julian in Paris. His West End School of Art in Provincetown, Mass., was a successful venture and included frequent tours to Europe. [J0068719]

30. GEORGE DE FOREST BRUSH (1855–1941), painter influenced by the Italian Renaissance and his studies with Jean-Léon Gérôme in Paris. Renowned for his paintings of Native Americans, he later added secularized Madonna images as one of his specialties. [J0001300]

31. CHARLES BURCHFIELD (1893–1967), modernist painter who celebrated nature in his watercolors. During his life, he often drew inspiration from his environs, which included small-town Salem, Ohio, and urban Buffalo, N.Y. [J0001324]

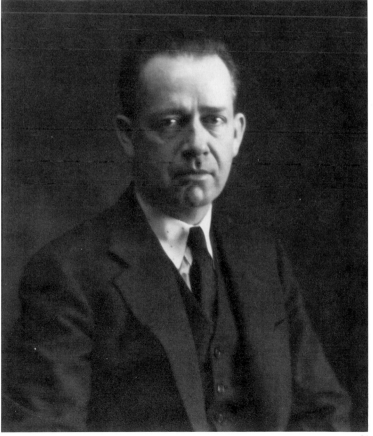

31

32. SELMA BURKE (1900–1995), sculptor and educator who received national recognition for her relief portrait of Franklin Delano Roosevelt, which was the model for his image on the dime. Committed to teaching art to others, Burke established the Selma Burke Art School in New York City in 1946 and subsequently opened the Selma Burke Art Center in Pittsburgh, Pa. [J0100404]

33. ALEXANDER CALDER (1898–1976), sculptor, world-renowned for his stabiles and mobiles begun in the 1930s. Calder's vision was broad and groundbreaking, and his output was prodigious—ranging from small figurines to large, architecturally related sculptures, from whimsical toys to stage sets. [J0050088]

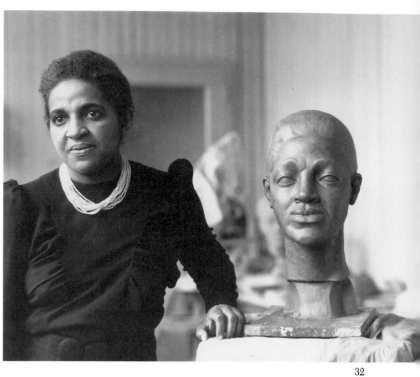

32

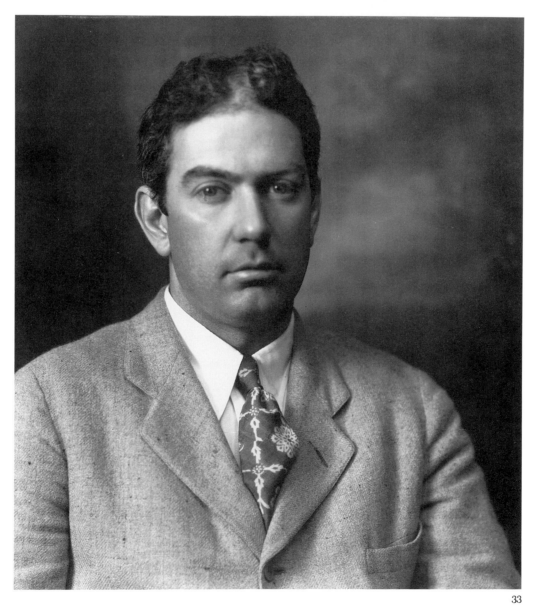

33

34. ALEXANDER STIRLING CALDER (1870–1945), sculptor who received numerous commissions, including the Depew Fountain (1915) in Indianapolis, Ind., the Swann Memorial Fountain in Philadelphia, Pa. (1924) and *Leif Ericson* (1932) in Reykjavik, Iceland. He was the son of sculptor Alexander Milne Calder and father of sculptor Alexander Calder. [J0050062]

35

36

37

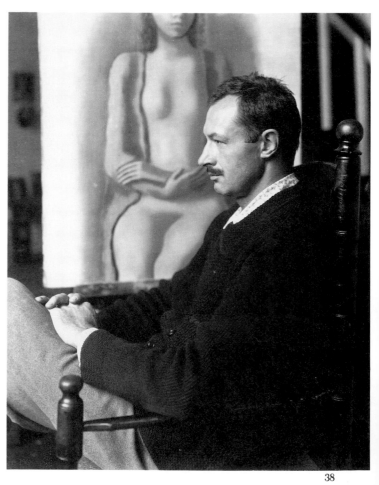

38

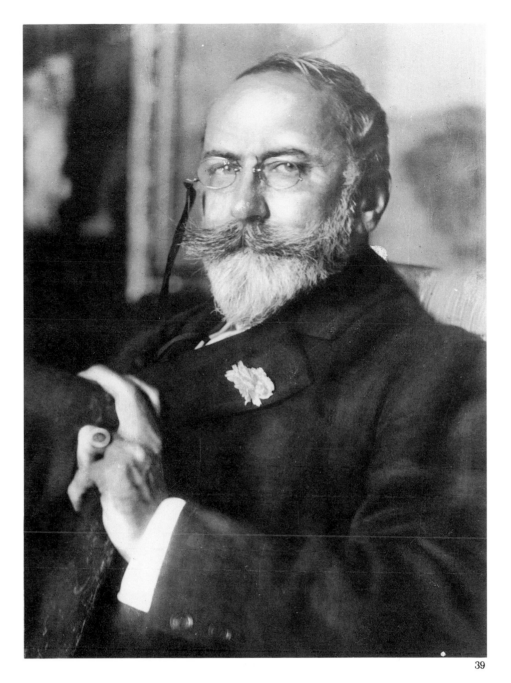

39

35. RHYS CAPARN (born 1909), sculptor whose subjects were animals, birds and the landscape rendered in semi-abstract forms. She was a student of the innovative sculptor Alexander Archipenko, who encouraged her exploration of European modernism at a time when the prevailing taste in the U.S. was social realism. [J0055545]

36. EMIL CARLSEN (1853–1932), still-life painter who first studied architecture in his homeland of Denmark and immigrated to the U.S. at age 19. Influenced by the master still-life painter Jean-Baptiste-Siméon Chardin, Carlsen was a leading exponent of the Chardin revival in France. [J0001336]

37. JOHN F. CARLSON (1874–1945), painter known particularly for his meditative winter scenes rendered in the tonalist tradition. Carlson also painted landscapes of the Far West and the Canadian Rockies, founded the John F. Carlson School of Landscape Painting in Woodstock,

N.Y., and authored *Elementary Principles of Landscape Painting* (1928). [J0105972]

38. JOHN CARROLL (1892–1959), painter. Carroll specialized in women's portraits executed in a light, delicate, wispy style; his wife, Georgia, was a frequent model. He was an early member of the artists' colony in Woodstock, N.Y., and, for many years, a teacher at the Art Students League. [J0001353]

39. WILLIAM MERRITT CHASE (1849–1916), painter and teacher. Chase's early paintings, executed in dark tonalities, reflected his training in Munich; his later paintings, most notably scenes of Shinnecock, Long Island, were painted with a lightened palette, reflecting the influence of French Impressionism. He had a lengthy teaching career at the Art Students League, the New York School of Art, the Pennsylvania Academy of the Fine Arts and the summer school he founded on Long Island. [J0001378]

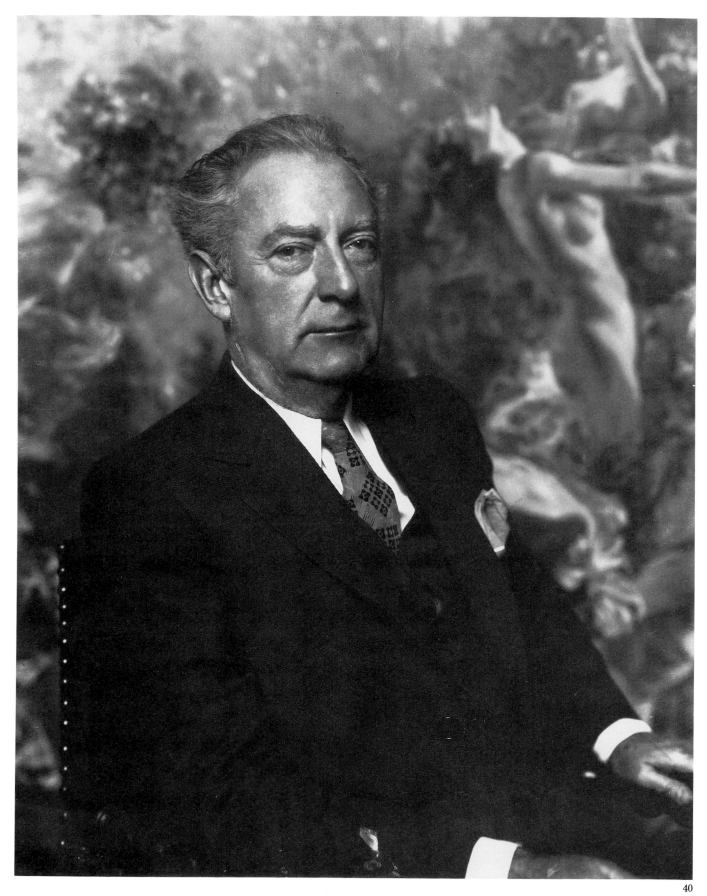

40. HOWARD CHANDLER CHRISTY (1873–1952), illustrator and portrait painter who created the "Christy Girl," an idealized American woman and successor to the "Gibson Girl." The "Christy Girl" appeared in numerous posters and magazine illustrations. His notable portraits included Amelia Earhart, Eddie Rickenbacker and Calvin Coolidge. [J0067501]

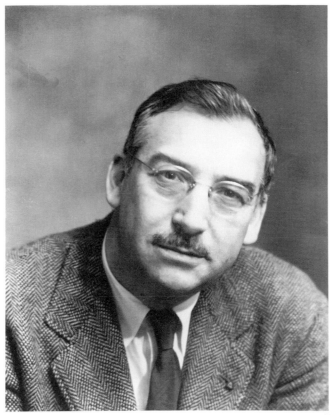

41

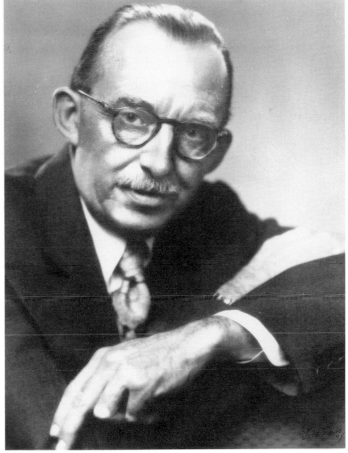

42

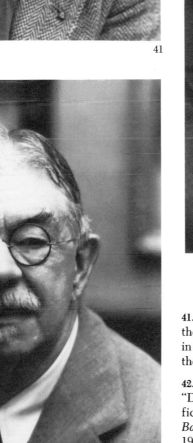

43

41. JON CORBINO (1905–1964), painter. In the style of the Baroque masters, he painted heroic animals and people in catastrophic, violent scenes. *Life* magazine dubbed him the modern-day Rubens. [J0001414]

42. DEAN CORNWELL (1892–1960), known as the "Dean of American Illustrators." His work accompanied fiction in *Redbook, The Saturday Evening Post, Harper's Bazaar, Cosmopolitan* and *The American Magazine.* In 1933 he completed 12 murals for the Los Angeles Public Library. [J0001408]

43. ROYAL CORTISSOZ (1869–1948), art critic. For more than 50 years, Cortissoz, a prolific and distinguished writer, was the art critic for the *New York Tribune,* later the *New York Herald Tribune.* He was a tireless advocate for traditionalism and an outspoken critic of modernism as represented in the work of such artists as Henri Matisse and Pablo Picasso. [J0008607]

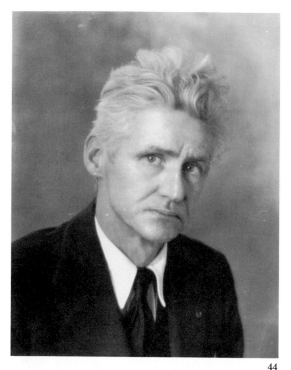

44. JOHN EDWARD COSTIGAN (1888–1972), self-taught painter and printmaker. The locale for Costigan's best-known paintings was his own farm in Orangeburg, N.Y.; the most frequent theme was life on the farm. [J0001413]

45. EANGER IRVING COUSE (1866–1936), painter. In some 1,500 paintings, he portrayed Native American life as peaceful and idyllic. Although he lived in New York City, he maintained a studio in Taos, N.M., for years before moving there permanently in 1928. [J0044555]

46. MIGUEL COVARRUBIAS (1904–1957), Mexican-born painter and draftsman. He created popular caricatures for *Vanity Fair* and the *New Yorker* and wrote and illustrated books on his travels. His interest in the ethnology and archaeology of Mexico led to his assembling a remarkable collection of pre-Columbian art, which was willed to the Mexico City National Museum of Anthropology. [J0008711]

44

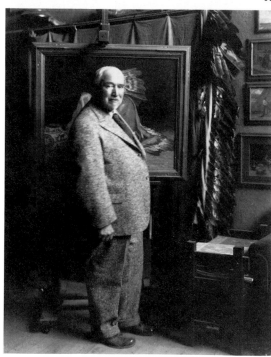

45

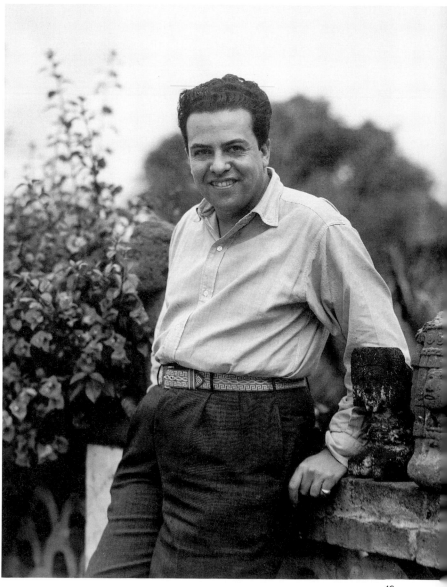

46

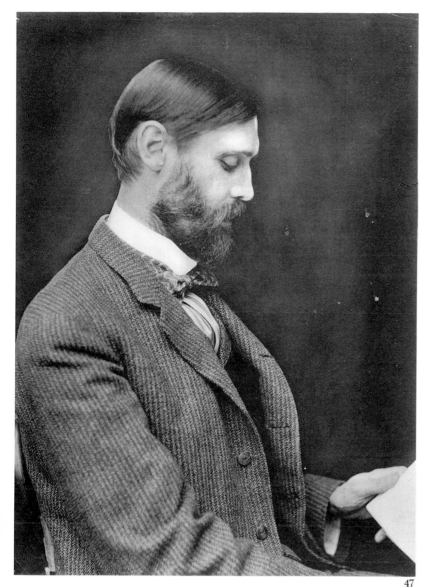

47

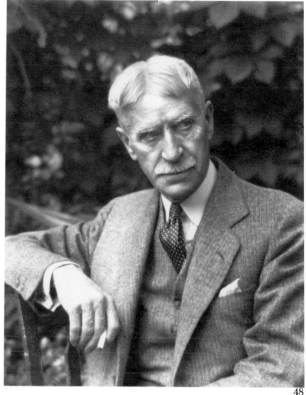

48

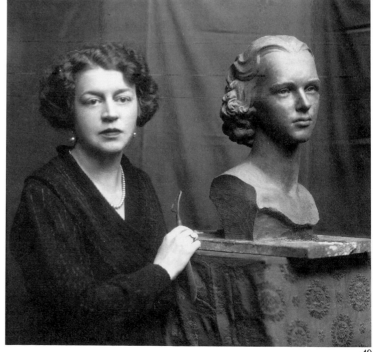

49

47. KENYON COX (1856–1919), critic, academic painter and muralist who studied in Paris with Jean-Léon Gérôme and Carolus-Duran. As a critic, he denounced modern currents in favor of classicism in *Old Masters and New* (1905), *The Classical Point of View* (1911) and *Concerning Painting* (1917). [J0001409]

48. BRUCE CRANE (1857–1937), painter who studied with tonalist A. H. Wyant and specialized in autumn scenes dominated by the color yellow; *Autumn Uplands* (ca. 1905) is an example. He was a president of the Salmagundi Club and an active member of the artists' colony in Old Lyme, Conn. [J0001425]

49. MARGARET FRENCH CRESSON (1889–1973), sculptor, daughter of sculptor Daniel Chester French. Portrait busts were Cresson's specialty; *Daniel Chester French* (1923), *Richard C. Byrd* (1927) and *The Unknown Soldier* (1940) are outstanding examples. In 1969 she donated Chesterwood, the 150-acre family estate and studio in western Massachusetts, to the National Trust for Historic Preservation. Today, Chesterwood operates as a public museum. [J0044747]

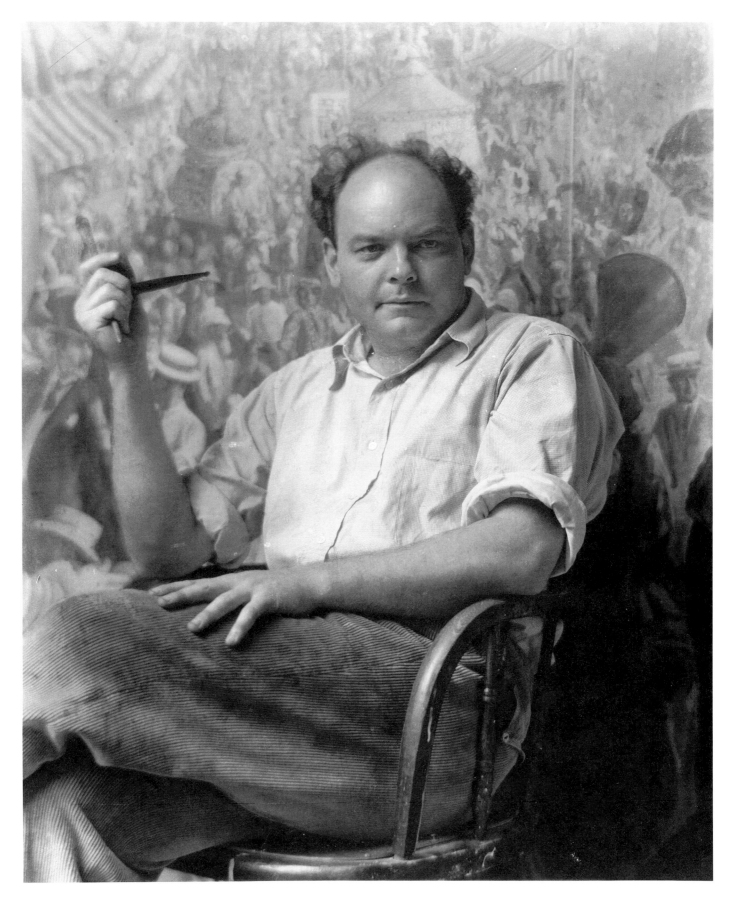

50. JOHN STEUART CURRY (1897–1946), painter. Like Grant Wood and Thomas Hart Benton, he was a major American scene painter of the 1930s. His subjects were taken from American history and his most famous mural, *The Tragic Prelude* (1938–40), is in Topeka at the Kansas State Capitol. [J0001430]

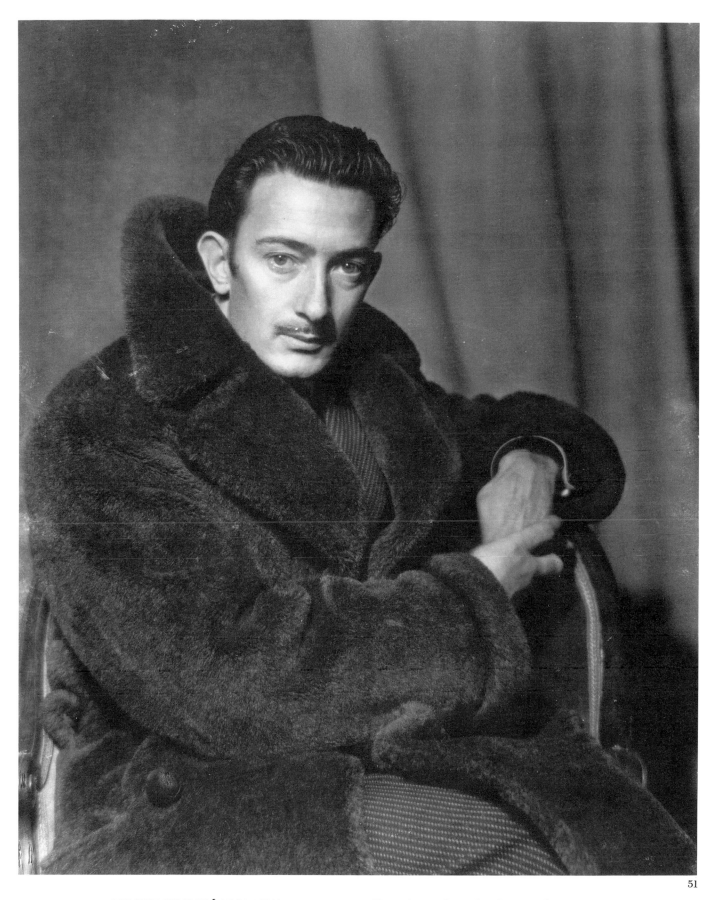

51. SALVADOR DALÍ (1904–1989), painter, writer, filmmaker and jewelry designer, born in Spain. Dalí's work was inspired by Surrealism and infused with metaphysical symbolism and visionary experiences. *Persistence of Memory* (1931) and *The Sacrament of The Last Supper* (1955) are widely known. [J0001443]

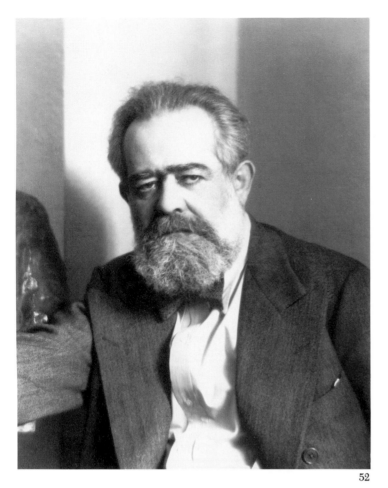

52. **JO DAVIDSON** (1883–1952), portrait sculptor, whose *raison d'être* was to sculpt the significant personalities of the 20th century. His work included naturalistic bronzes of Woodrow Wilson, Herbert Hoover, Fiorello La Guardia, Gertrude Stein, Anatole France, Mahatma Gandhi, Rudyard Kipling and Franklin Delano Roosevelt. [J0001438]

53. **ARTHUR B. DAVIES** (1862–1928), painter, printmaker, sculptor, tapestry designer and illustrator who was known as a contradictory, enigmatic and mystical artist. Although he was not a realist, Davies exhibited with The Eight in New York City in 1908, and while he was not considered a modernist either, he selected some of the most avant-garde work of the day as organizer of the famous 1913 Armory Show. [J0001442]

52

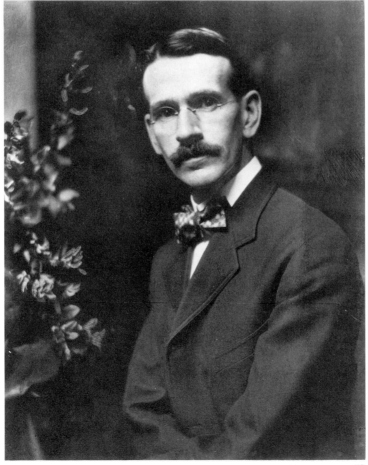

53

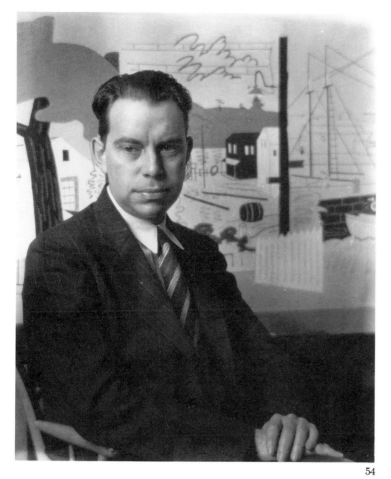

54

54. STUART DAVIS (1894–1964), pioneer modernist painter who exhibited at the 1913 New York Armory Show. Davis believed that "a subject had its emotional reality," which could be gleaned through an awareness of geometric planes and spatial relationships. Davis spent a year exploring the same subject in his famous *Eggbeaters* series (1927–28). [J0001440]

55. JOSÉ DE CREEFT (1884–1982), sculptor. In 1929, after studying in Paris, de Creeft immigrated to the United States from Spain. He popularized direct stone carving through his female heads and figures; his experiments with hammered lead were also innovative. [J0001463]

56. ADOLF DEHN (1895–1968), lithographer and painter, known for his satire. As a young artist, Dehn concentrated on printmaking and created over 600 lithographs before 1936; afterwards, he turned increasingly to watercolor. He also taught at the Colorado Springs Fine Arts Center and authored three books, including *Water Color Painting* (1945). [J0001444]

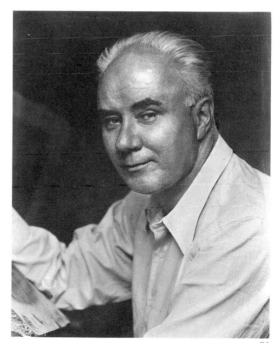

56

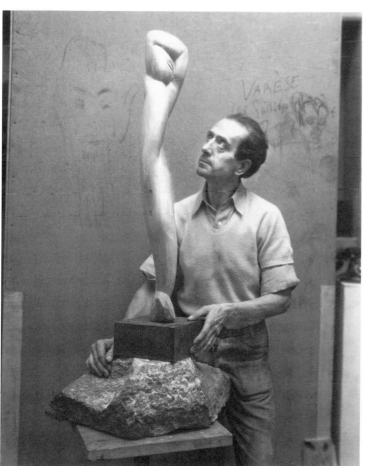

55

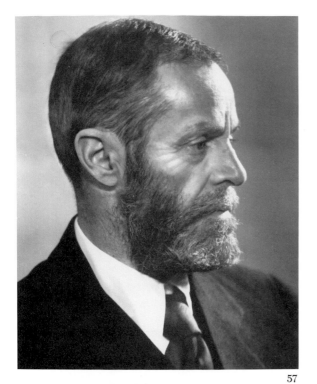

57

57. EDWIN DICKINSON (1891–1978), painter whose highly individual, representational work was well regarded by modernist schools for its imaginative and skillful display of perspective drawing, color values and Surreal overtones. *The Fossil Hunters* (1926–28) is a well-known and controversial painting. Dickinson studied art with Charles Hawthorne. [J0001487]

58. SIDNEY E. DICKINSON (with family; 1890–1980), portrait painter. Cousin of Edwin Dickinson, he studied with George Bridgman and William Merritt Chase at the National Academy of Design and the Art Students League, eventually becoming an instructor at the latter. [J0069681]

59. MARCEL DUCHAMP (1887–1968), avant-garde artist, born in France, who created a *succès de scandale* with his *Nude Descending a Staircase* at the 1913 New York Armory Show. A leader in the international Dada movement, he stopped painting in 1918 and turned to chess, collages, optical machines and constructions. [J0001502]

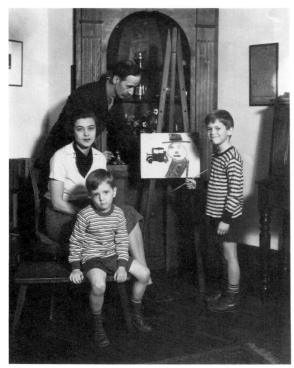

58

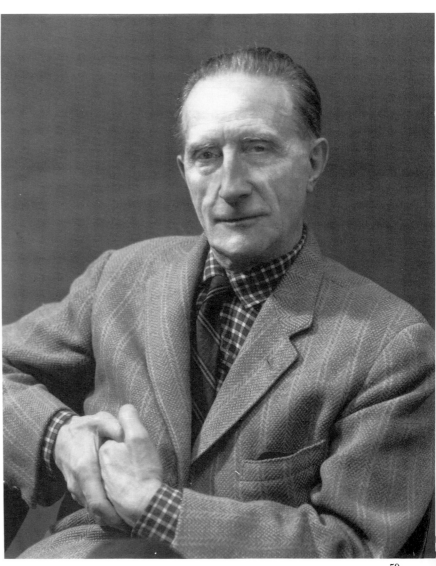

59

60. FRANK VINCENT DUMOND (1865–1951), landscape and portrait painter. As a beloved teacher at the Art Students League for 59 years, he counted among his many students John Marin, Eugene Speicher, Norman Rockwell, Georgia O'Keeffe and Marsden Hartley. [J0001516]

61. FRANK DUVENECK (1848–1919), Kentucky-born painter and teacher. He studied at the Munich Academy and developed a loose, broad painting style in the manner of Hals and Rembrandt. *Whistling Boy* (1872) is a signature work. [J0001495]

62. JACOB EPSTEIN (1880–1959), sculptor who emigrated from the U.S. to England and became one of the country's leading artists. His portrait and figure work was well received and included depictions of Paul Robeson, T. S. Eliot and John Gielgud. His public commissions, however, were frequently assailed as modernism at its worst. [J0001536]

60

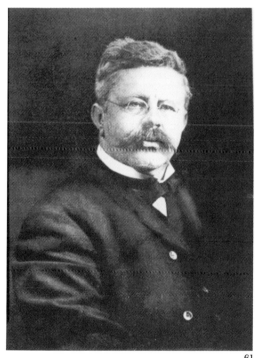

61

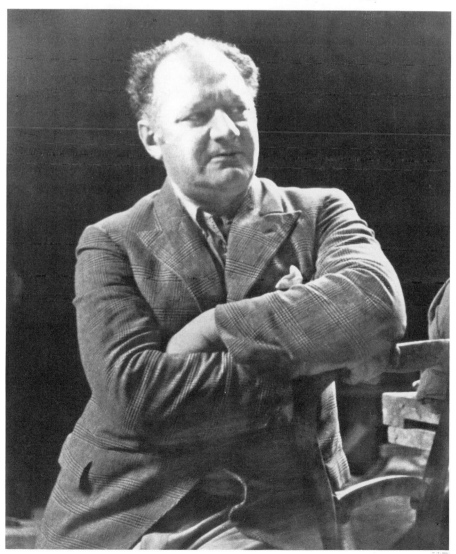

62

25

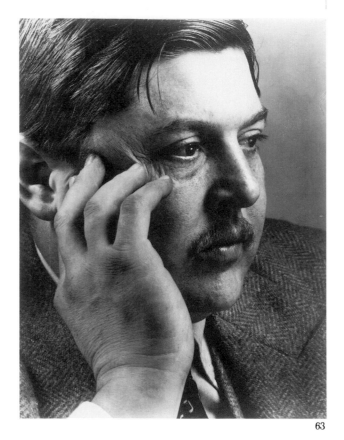

63. PHILIP EVERGOOD (1901–1973), painter and muralist. His experiences in the Great Depression led him to turn from biblical subjects to social criticism. He was also active in organizations devoted to the civil rights of artists. [J0001524]

64. ELTON FAX (1909–1993), portrait painter and freelance illustrator who completed more than 30 children's books. He wrote about African-American artists in his book *Seventeen Black Artists* (1971). [J0117315]

63

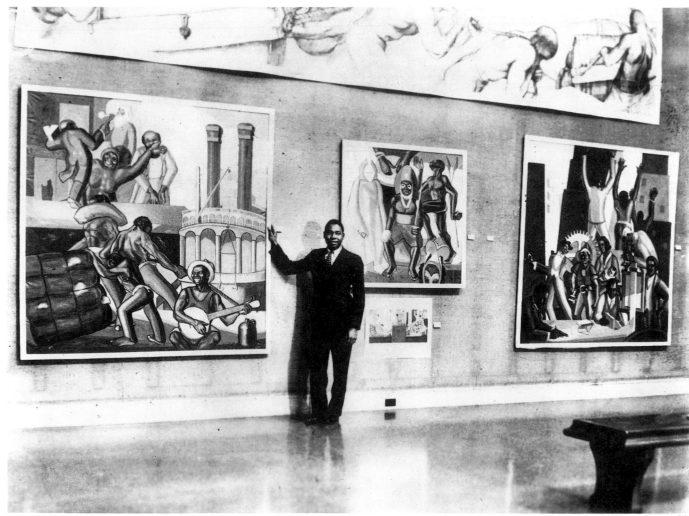

64

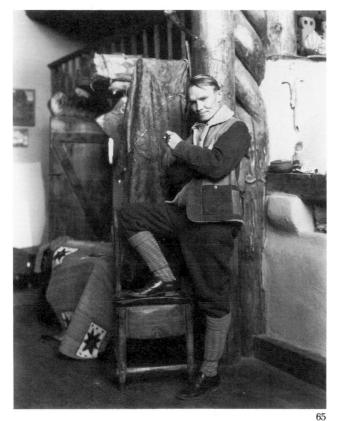

65

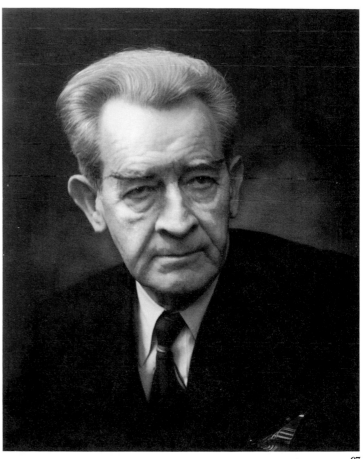

65. NICOLAI FECHIN (1881–1955), painter, sculptor. By the time Fechin immigrated to the United States from Russia in 1923, he had developed his palette-knife technique and had many professional successes. He settled in Taos, N.M., painting the landscape and its people. In addition, he built a remarkable house and studio, resplendent in carved woodwork and furniture he created, which has since become a state historical site. [J0001597]

66. ERNEST FIENE (1894–1965), painter. He was an extremely versatile artist who worked in several mediums and whose subject matter included landscapes, portraits and the American experience in industry and labor. His 2000-square-foot fresco mural, created for New York's High School of Needle Trades, contains over 200 figures. [J0069275]

67. JAMES MONTGOMERY FLAGG (1877–1960), painter and illustrator for *St. Nicholas Magazine, Judge, Life, Harper's Weekly, College Humor* and *Cosmopolitan*. He sold his first illustration at age 12 and is best remembered for his *I Want You*, a World War I poster of Uncle Sam, for which he served as model. [J0001599]

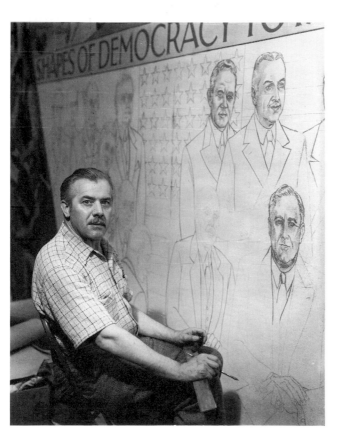

66

67

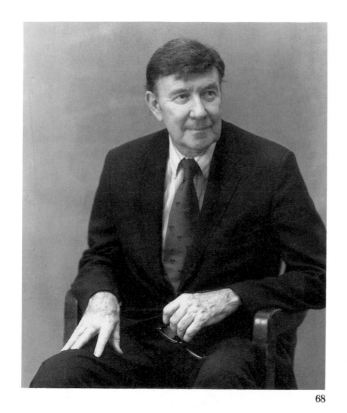

68. THOMAS FOGARTY (1873–1938), illustrator and teacher. *The Making of an American* by Jacob Riis, *On Fortune's Road* by Will Payne and *The Friendly Road* by David Grayson are among the books he illustrated. A famous teacher at the Art Students League, Fogarty counted McClelland Barclay and Norman Rockwell among his more successful students. [J001608]

69. JAMES EARLE FRASER (1876–1953), sculptor and assistant to Augustus Saint-Gaudens. Fraser designed the buffalo nickel and his *End of the Trail* (1915), an image of an exhausted Indian hunched over his tired horse, is one of the most recognized sculptures of the American West. [J0103257]

68

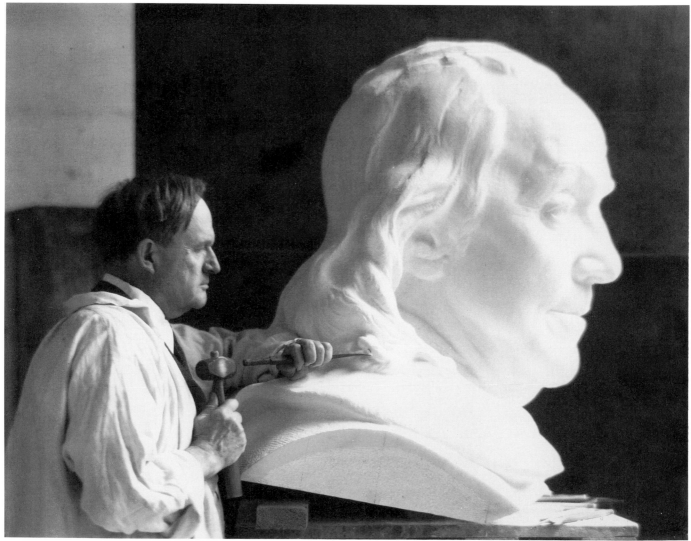

69

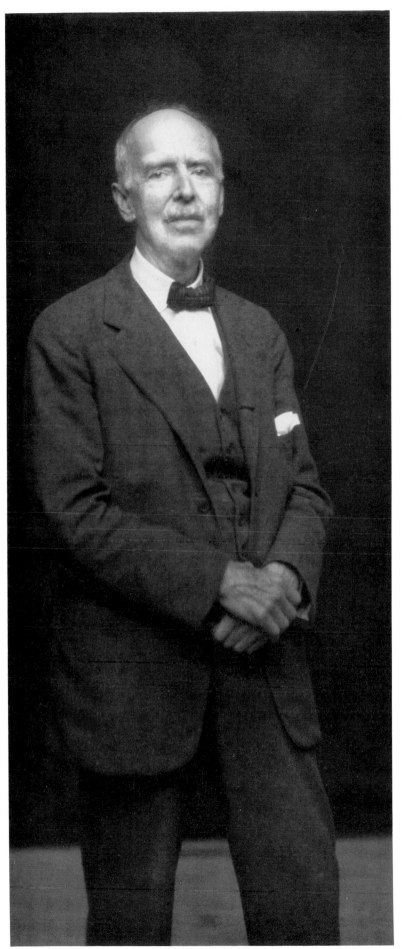

70

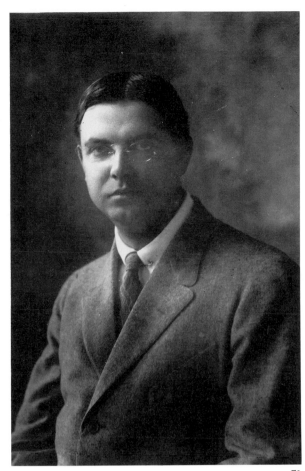

71

70. DANIEL CHESTER FRENCH (1850–1931), sculptor. Fame came early with *The Minute Man* (1875) at Concord, Mass., and he quickly moved to the fore-front of American sculpture, creating allegorical figures in the Neoclassical style. He also created the seated figure of Abraham Lincoln in the Lincoln Memorial, Washington, D.C., dedicated in 1922. [J0001558]

71. FREDERICK CARL FRIESEKE (1874–1939), an American Impressionist painter whose early work was influenced by James Abbott McNeill Whistler and whose later work strongly reflected the explorations of the French Impressionists. His paintings of voluptuous full-bodied women, many painted at his country home in Giverny, France, recall the work of Pierre Auguste Renoir. [J0001564]

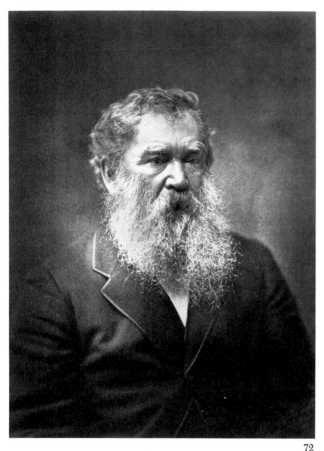

72

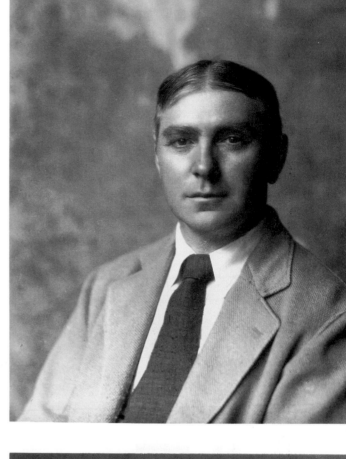

73

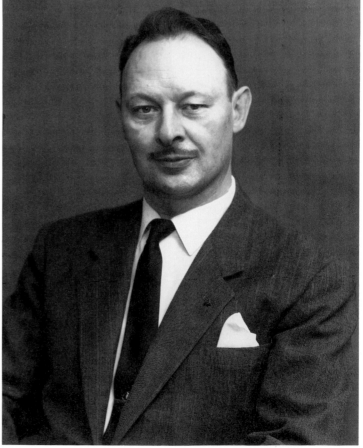

74

72. GEORGE FULLER (1822–1884), painter and tobacco farmer from Deerfield, Mass. He experimented with light in his landscape and portrait paintings, often imbuing them with a dreamy and mysterious atmosphere. [J0122207]

73. DANIEL GARBER (1880–1958), painter. Garber was long associated with the Pennsylvania Academy of the Fine Arts, first as a student and then as an instructor. In his landscape paintings, a single tree often dominates the foreground. [J0014061]

74. HENRY MARTIN GASSER (1909–1981), painter, teacher and writer. A native of Newark, N.J., Gasser studied at the Newark School of Fine and Industrial Art and served as its director from 1946–54. He wrote *Oil Paintings: Methods and Demonstrations* (1953), *Techniques of Painting the Waterfront* (1959) and *Techniques of Picture Making* (1963). [J0001637]

75. CHARLES DANA GIBSON (1867–1944), illustrator. His "Gibson Girl" was the model of American womanhood in the 1890s and into the early 20th century. The stylish, humorous illustrations he created appeared frequently in *Life* and *Harper's*. [J0001674]

76. WILLIAM GLACKENS (1870–1938), painter, illustrator and member of The Eight. At the beginning of his career, Glackens painted scenes of middle-class life and used a rich, dark palette; in later years, he favored still lifes and studio scenes, his colors reflecting the influence of Pierre Auguste Renoir. [J0001678]

75

76

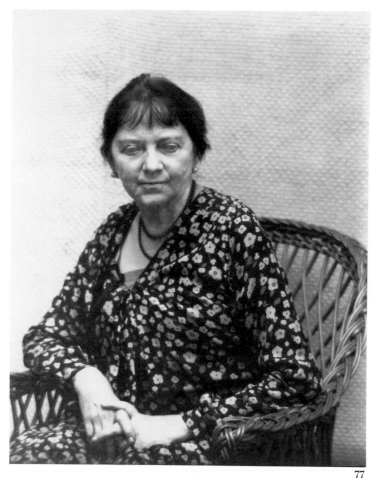

77

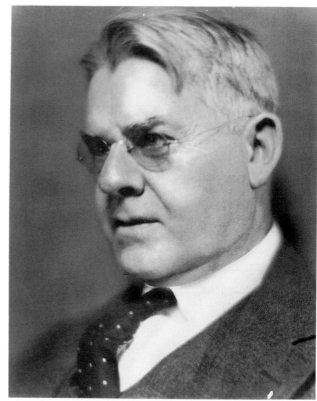

78

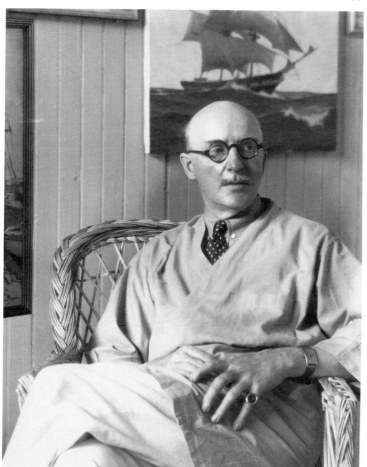

79

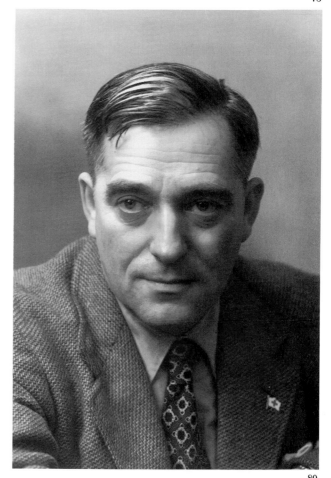

80

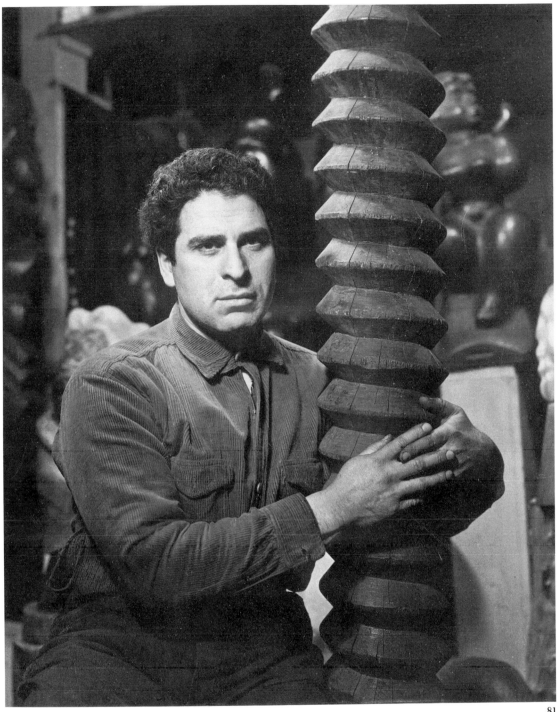

81

77. ANNE GOLDTHWAITE (1869–1944), painter and etcher born during the Reconstruction era in Montgomery, Ala. She studied in New York at the National Academy of Design and in Paris with Charles Guérin. She established herself principally as a recorder of the South's past. [J0001675]

78. FREDERIC W. GOUDY (1865–1947), type designer. He created over 100 typefaces, including Kennerly and Goudy Antique. [J0001676]

79. GORDON HOPE GRANT (1875–1962), marine and naval painter. Born in San Francisco, Grant studied at the Heatherly Art School of London; his specialty was depictions of historic sailing vessels, such as *Old Ironsides* (1927). [J0001635]

80. WILLIAM GROPPER (1897–1977), cartoonist and social realist painter who studied with Robert Henri and George Bellows. Often compared with Honoré Daumier, Gropper was a satirical cartoonist for the *New York Tribune*. He contributed to *Vanity Fair*, as well as to more radical publications such as the *Masses* and the *Liberator*, and to two Communist publications—*Freiheit* and the *Daily Worker*. [J0001655]

81. CHAIM GROSS (1904–1991), sculptor. Born in Austria, Gross studied in Budapest and Vienna before settling in the United States in 1921. Gross sculpted in wood, using a direct carving technique. He is best known for his semi-abstract interpretations of the human form. [J0017924]

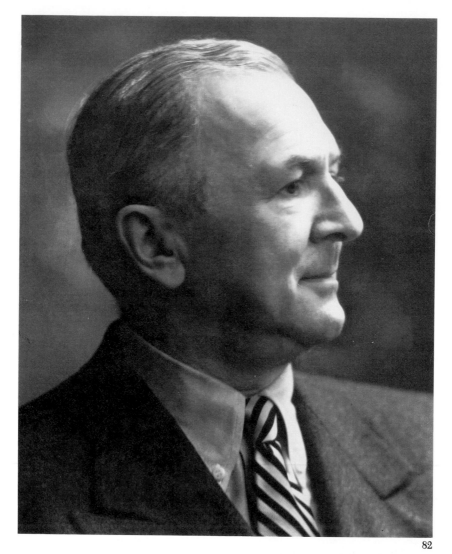

82

82. GEORGE GROSZ (1893–1959), Expressionist painter and printmaker. During his career, Grosz was variously linked to three modern art movements—Dada and Die Neue Sachlichkeit in Germany and, after his immigration to the United States, American social realism of the 1930s and 1940s. [J0001658]

83. JOHN GROTH (1908–1988), artist-correspondent and first art director of *Esquire Magazine*. He vividly captured the combat of five wars, including Vietnam, in his illustrations. [J0001642]

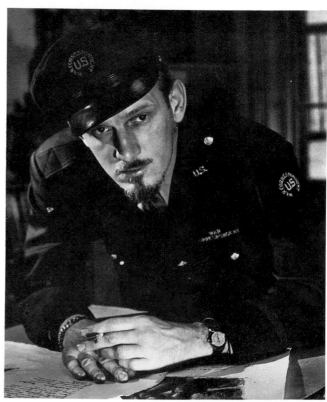

83

84

85

86

84. EMILE ALBERT GRUPPE (1896–1978), painter. His paintings of sailboats and fishing vessels were often dramatically composed. Gruppe was from a family of painters—his father, brother, sister and nephew were artists. He painted in and around Gloucester, Mass., where he opened and directed the Gloucester School of Painting from 1940 to 1970. [J0001650]

85. ROBERT GWATHMEY (1903–1988), painter, born in Richmond, Va. Socially conscious, Gwathmey portrayed rural African-American life in the South in a modernist style, emphasizing broad areas of color outlined in black. [J0001660]

86. HERBERT HASELTINE (1877–1962), outstanding equestrian sculptor. He was the son of painter William Stanley Haseltine. Examples of his work include *Man o' War*, located at the thoroughbred's grave in Lexington, Ky., and *Field Marshall Sir John Dill* at Arlington Cemetery. [J0001686]

87

87. CHILDE HASSAM (1859–1935), painter and illustrator. Hassam was a leading American Impressionist whose work was much influenced by Claude Monet. His landscapes, street scenes and interior scenes were both popularly and officially recognized. [J0001736]

88. CHARLES W. HAWTHORNE (1872–1930), portrait and genre painter who studied with George de Forest Brush at the Art Students League and William Merritt Chase at Shinnecock, Long Island. He was also founder and dynamic director of the Cape Cod School of Art in Provincetown, Mass. [J0048026]

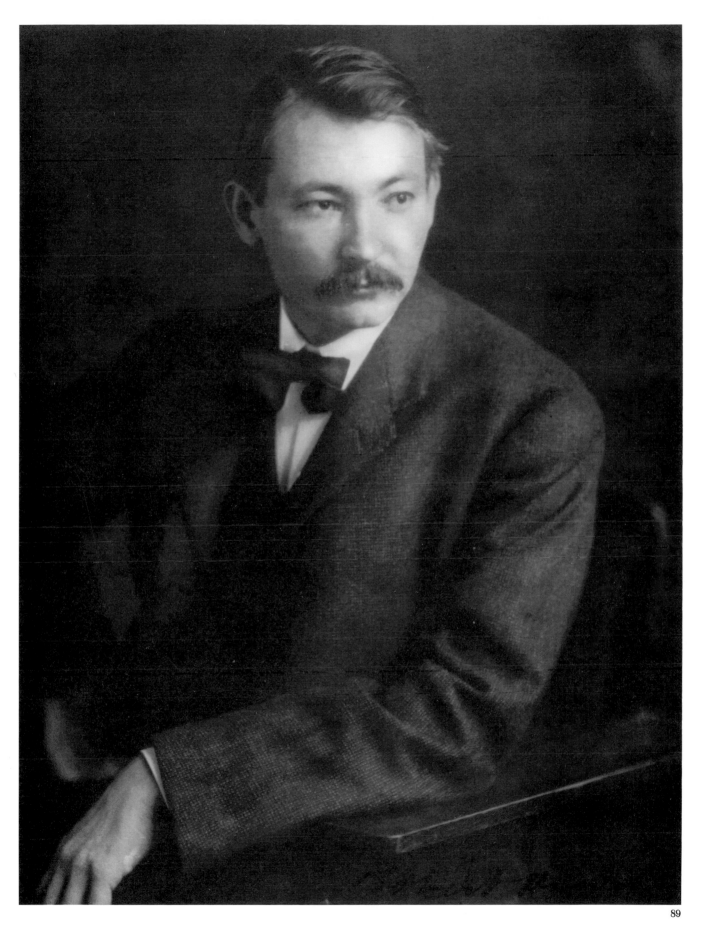

89. ROBERT HENRI (1865–1929), painter and master teacher. A member of The Eight, he led a crusade away from traditional academic painting and sought to link art with life, not theories. A whole generation of young artists, including George Bellows, Stuart Davis, Yasuo Kuniyoshi, Edward Hopper, Morgan Russell and Rockwell Kent, were inspired by Henri's teachings. [J0001714]

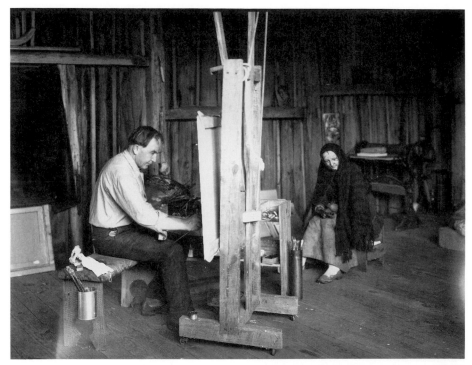

90

91

92

90. EUGENE HIGGINS (with unidentified model; 1874–1958), painter and printmaker. Higgins worked in the tradition of Jean-François Millet and Honoré Daumier; he expressed his humanitarian interests in portrayals of the poor and downtrodden. [J0001713]

91. FELRATH HINES (1913–1993), painter. Hines studied design at the Pratt Institute in Brooklyn, N.Y., and his paintings—in the tradition of the De Stijl movement—often contain strong design elements. His work moved from semiabstract landscapes in the 1940s and 1950s to geometric abstracts. The artist served as a conservator at several institutions, including the Hirshhorn Museum and Sculpture Garden, Washington, D.C. [J0001701]

92. JOSEPH HIRSCH (1910–1981), realist painter whose work was often socially oriented and imbued with humanism. During World War II, he served as an artist-correspondent for the U.S. government. [J0001699]

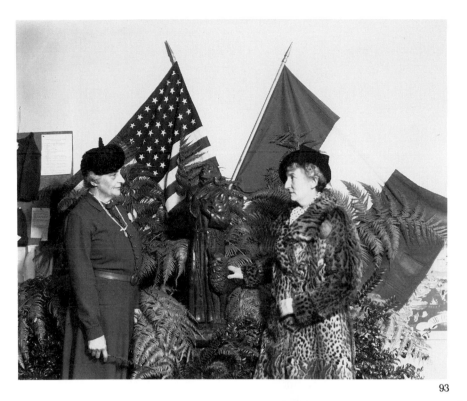

93. MALVINA HOFFMAN (right, with un-identified woman; 1887–1966), sculptor. She studied painting with John White Alexander at the Art Students League and sculpture with Gutzon Borglum and Auguste Rodin. On commission from the Field Museum of Natural History in Chicago, she sculpted for exhibition display 100 ethnic types, which she titled the *Living Races of Man* (1929–1933). [J0001709]

94. HANS HOFMANN (1880–1966), painter. A German American, Hofmann was a leading Abstract Expressionist painter and was considered to be one of the greatest 20th-century teachers. He directed his own school in Munich and taught at both the University of California at Berkeley and his own school in New York. Hofmann's talent was recognized in retrospectives at the Baltimore Museum of Art (1954), the Whitney Museum of Art (1957) and The Museum of Modern Art (1963). [J0001704]

95

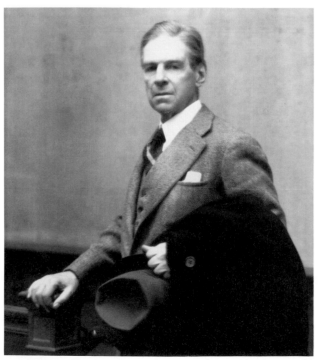

96

95. WINSLOW HOMER (1836–1910), painter and graphic artist. Homer's illustrations of the Civil War for *Harper's Weekly* are singular and outstanding examples of wartime reporting. Later, his dramatic paintings of the sea, many of which were completed at his seacoast home in Prout's Neck, Me., established Homer as a leading American artist. [J0001697]

96. CHARLES HOPKINSON (1869–1962), preeminent portrait painter, who received over 450 commissions in his lifetime. He was one of eight Americans selected to paint victorious allied leaders at the Versailles Peace Conference in 1919. [J0035188]

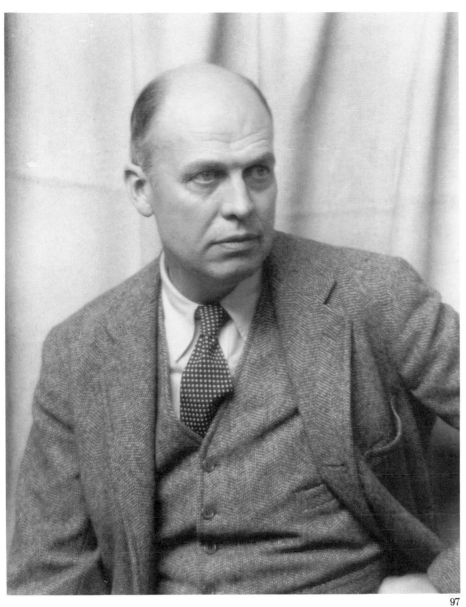

97

97. EDWARD HOPPER (1882–1967), realist painter who studied with Robert Henri and Kenneth Hayes Miller at the New York School of Art. One of the country's most honored artists, Hopper was internationally acclaimed in his lifetime and was elected to both the National Institute of Arts and Letters (1945) and the American Academy of Arts and Letters (1955). He poetically painted the isolation and detachment of modern life; *Nighthawks* (1942) is arguably his best-known composition. [J0001707]

98. ANNA VAUGHN HYATT HUNTINGTON (1876–1973), sculptor and benefactress whose specialty was animal and garden sculpture. She established and designed the country's first outdoor sculpture museum, Brookgreen Gardens, in S.C. [J0001729]

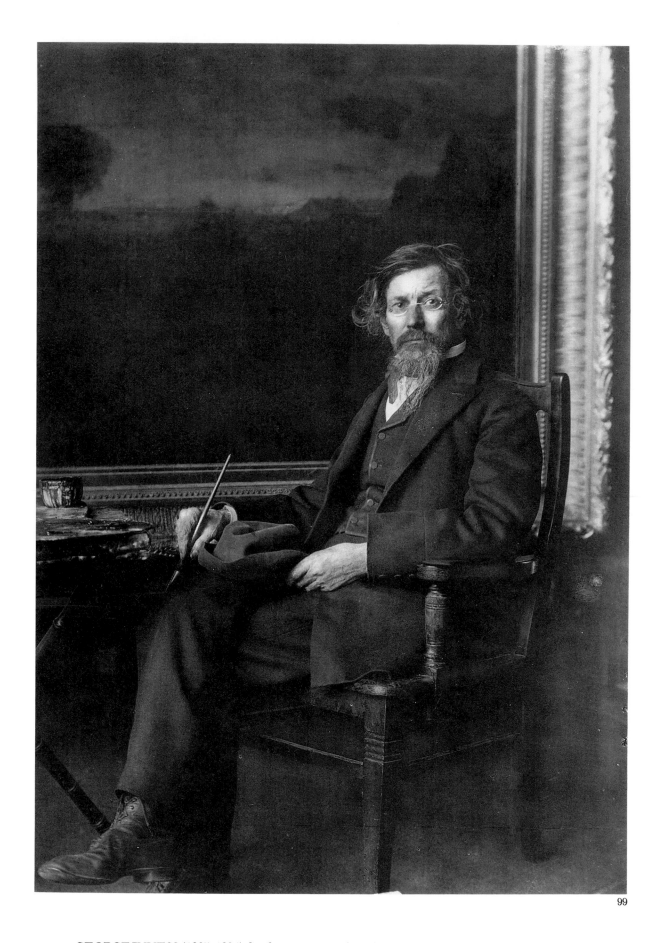

99. GEORGE INNESS (1825–1894), landscape painter, largely self-taught. Inness absorbed influences of the Barbizon and Hudson River Schools. The rich colors and emotional intensity in his later works were likely derived from his study of the pantheistic philosophy of Emanuel Swedenborg. [J0001737]

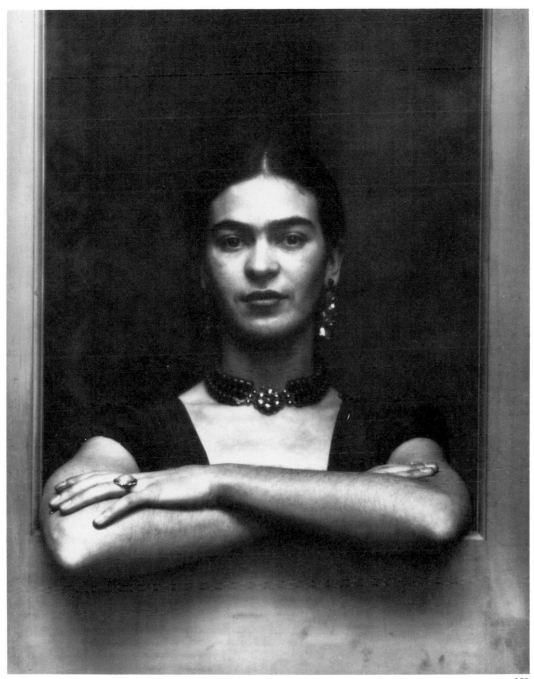

100

100. FRIDA KAHLO (1910–1954), painter, Mexican. After a serious accident, Kahlo turned to painting. Her highly personal and emotionally charged work documents and interprets her long periods of illness and her stormy union with her husband, artist Diego Rivera. [J00033263]

101. MORRIS KANTOR (1896–1974), Russian-born painter. Kantor's artistic explorations started with a semi-abstract style born from Cubism; his later style was realistic with fanciful elements. [J0007349]

102. BERNARD KARFIOL (1886–1952), painter, born in Budapest, Hungary, and raised in New York City. Karfiol's work, revealing the influences of Pierre Auguste Renoir and Paul Cézanne, is comprised primarily of nudes and still lifes. [J0001750]

103. WILLIAM SERGEANT KENDALL (1869–1938), painter and sculptor. Kendall studied with Thomas Eakins in Philadelphia and is best known for his portraits of women and children. [J0099290]

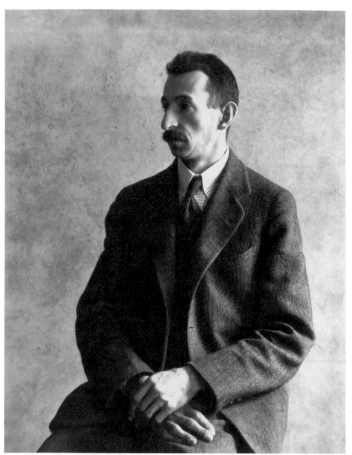

101

102

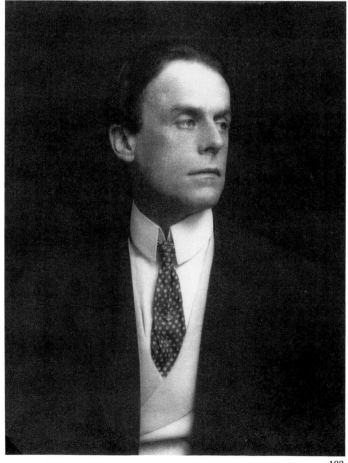

103

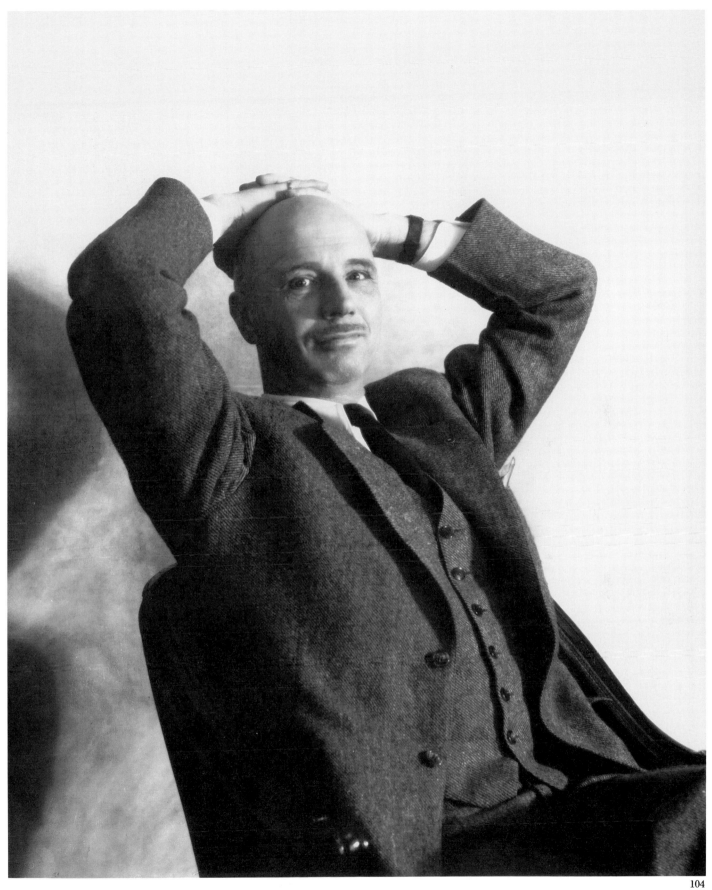

104. ROCKWELL KENT (1882–1971), painter, graphic artist and writer. He developed a signature style of sculptural characterizations and traveled widely, illustrating his accounts of trips to Greenland, Alaska and the Strait of Magellan. Politically active throughout his life, he received the Lenin Peace Prize—the Soviet-bloc counterpart to the Nobel Prize for peace—in 1967. [J0001817]

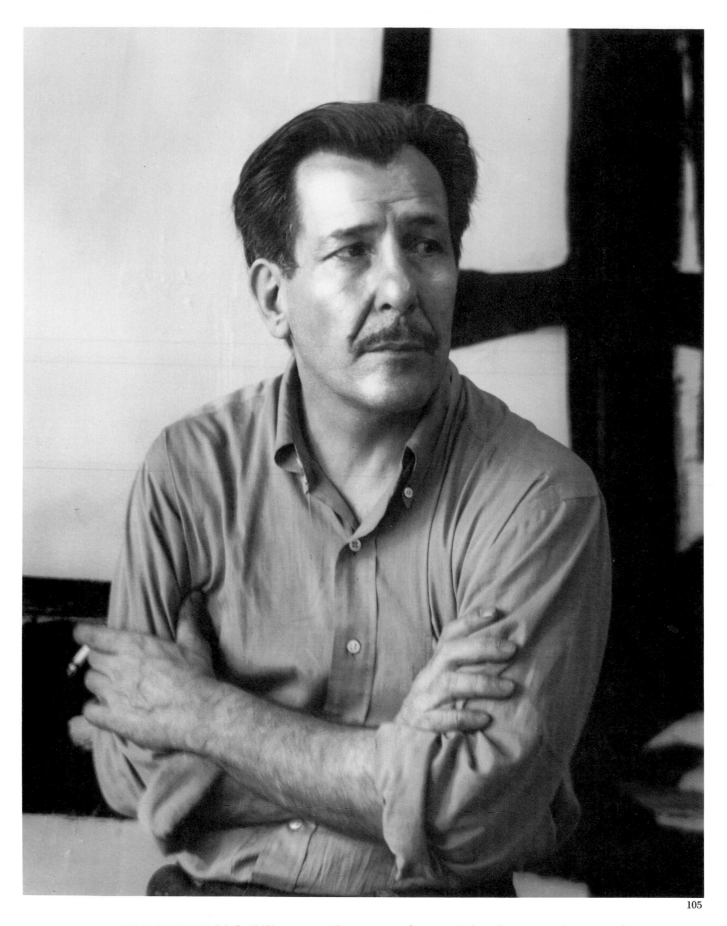

105

105. FRANZ KLINE (1910–1962), painter, Abstract Expressionist. Early in his career, Kline painted landscapes, street scenes and portraits. His mature style was abstract, distinctive for its broad, highly charged black strokes on a white ground. [J0001779]

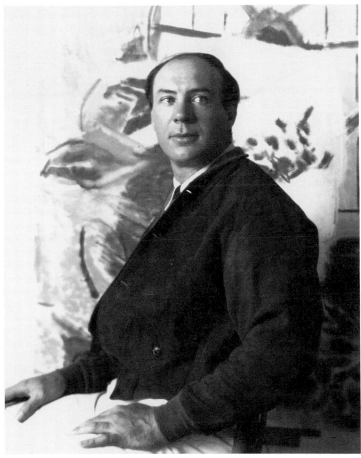

106

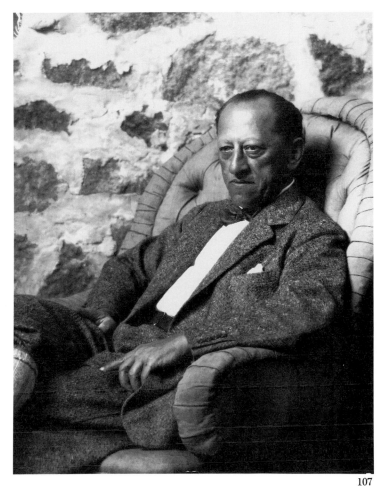

107

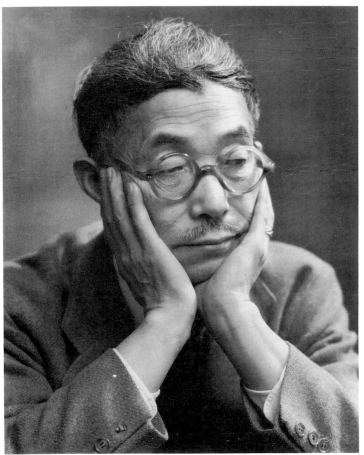

108

106. KARL KNATHS (1891–1971), painter. Knaths applied his system of color theory to his abstract landscapes and scenic depictions, which were highly Cubist in style. He was a favorite of patron Duncan Phillips (Phillips Collection, Washington, D.C.), who purchased the first painting Knaths sold (1926) as well as many subsequent works. [J0020780]

107. LEON KROLL (1884–1974), painter. A traditionalist, Kroll executed murals, landscapes and nudes. He won first prize at the 1936 Carnegie International Exhibition for the painting *The Road from the Cove.* [J0001784]

108. YASUO KUNIYOSHI (1893–1953), painter and photographer of art. His languid women in repose from the 1930s are significant, but he also painted still lifes and landscapes. He was the first president of Artists Equity and cofounder of the American Artists Congress. [J0001791]

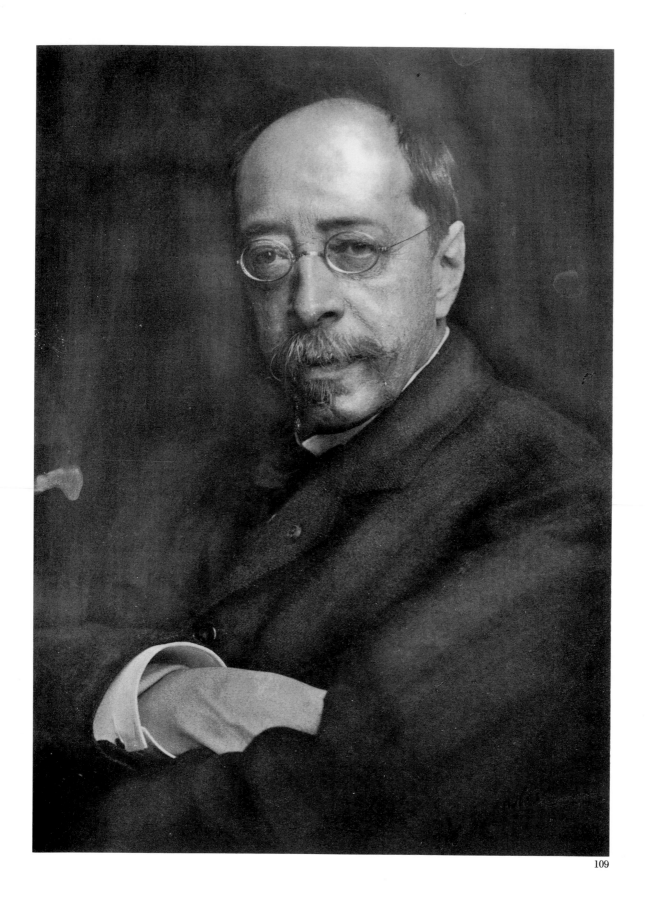

109

109. JOHN LA FARGE (1835–1910), painter, stained glass designer. Among his many commissions, decoration of the Trinity Church in Boston placed La Farge at the forefront of the American Arts and Crafts movement. He early admired the formality and patterning of Japanese art, and he recorded his impressions of his travels in Asia in *An Artist's Letters from Japan* (1897). [J0001833]

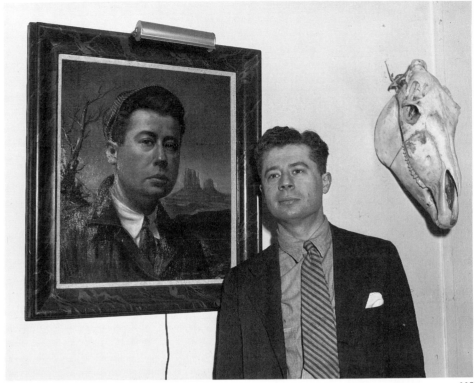

110

110. **EDWARD LANING** (1906–1981), painter and muralist. In his work, Laning expressed his disenchantment with the political and social uncertainties of post-Depression America and his perception of the degradation of American values; in several paintings he used fire as a symbol of impending societal destruction. [J0077972]

111. **ROBERT LAURENT** (1890–1970), sculptor. Laurent was a modernist who pioneered direct carving in the United States. Nature and abstraction blended in his works in wood, alabaster, bronze and marble. *Goose Girl* (1932), at Radio City Music Hall in New York City, is his best-known commission. [J0001846]

111

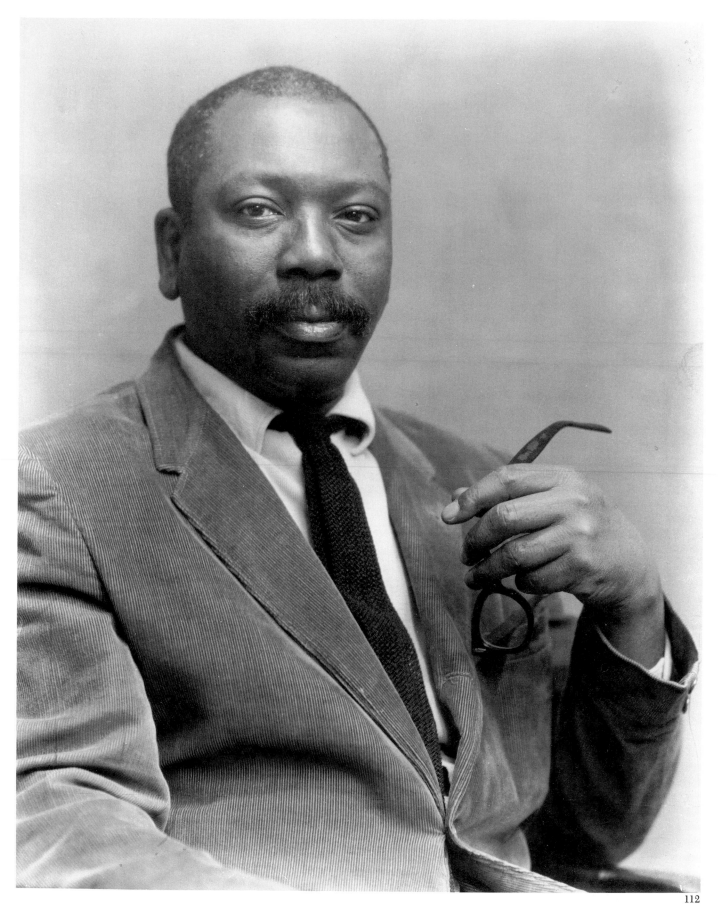

112. JACOB LAWRENCE (born 1917), painter. A social realist, Lawrence documented the African-American experience in several series devoted to Toussaint L'Ouverture, Frederick Douglass, Harriet Tubman, life in Harlem and the civil rights movement of the 1960s. He was one of the first nationally recognized African-American artists. [J0001840]

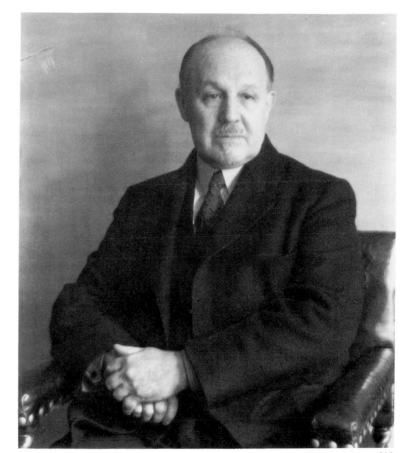

113. ERNEST LAWSON (1873–1939), painter, the only landscape painter among The Eight. Influenced by French Impressionism and the Impressionism of American artists John Henry Twachtman and Julian Alden Weir, he had a preference for painting winter scenes along the Hudson and Harlem Rivers. Stylistically, Lawson's work was characterized by his use of heavy impasto. [J0001834]

114. WILLIAM ROBINSON LEIGH (1866–1955), painter of the American West, writer. Leigh's love of nature was kindled during his youth in W.Va. Reputedly, he was a direct descendant of Pocahontas, and his interest in Native American life was sparked by his legacy. As a field artist for the American Museum of Natural History, he visited East Africa in 1926 and 1928 and painted wild animals. Leigh also wrote books and short stories. [J0010482]

113

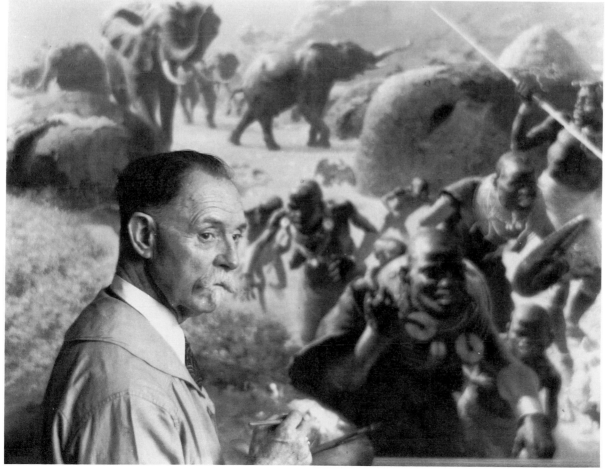

114

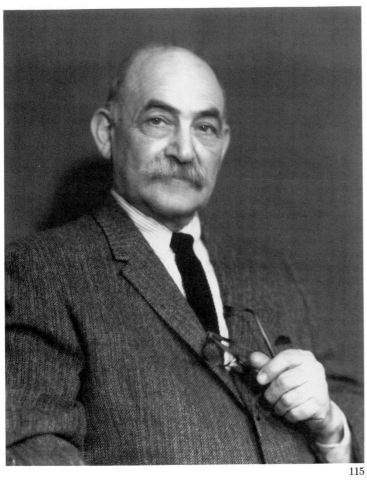

115

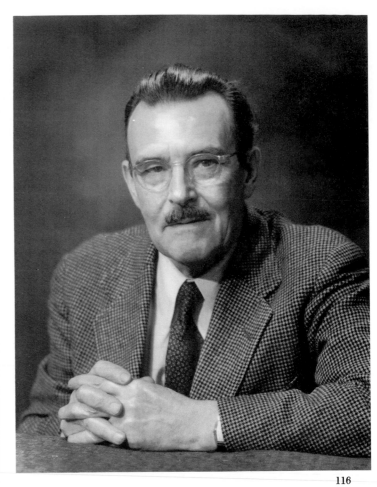

116

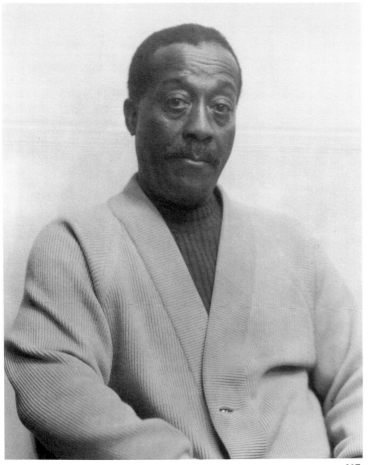

117

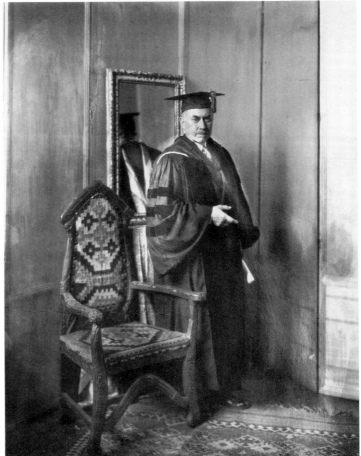

118

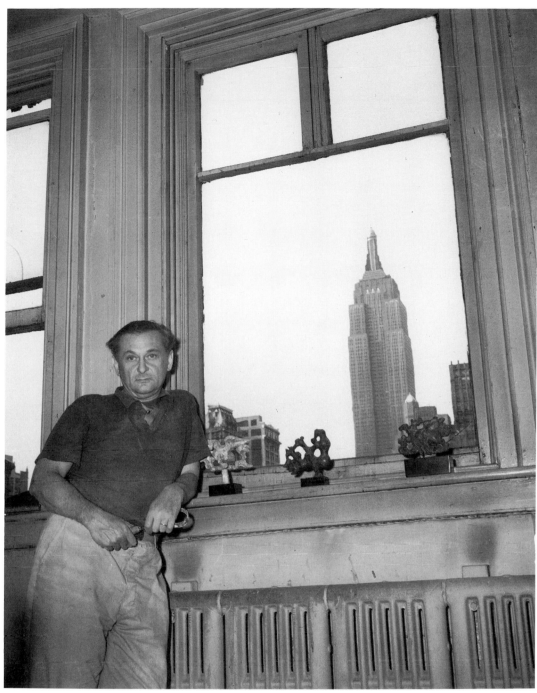

119

115. JULIAN E. LEVI (1900–1982), painter who studied with Arthur Carles and Henry McCarter at the Pennsylvania Academy of the Fine Arts. His style progressed from Cubist abstraction to realism with a touch of Surrealism; the sea was his preferred subject. [J0001861]

116. MARTIN LEWIS (1881–1962), a printmaker who specialized in etching and drypoint. He is known for his realistic urban scenes, many of which were night views. [J0001865]

117. NORMAN LEWIS (1909–1979), painter, Abstract Expressionist. As the only African-American artist in the New York School, Lewis exhibited at the Willard Gallery in New York City along with Morris Graves and David Smith. [J0001863]

118. JONAS LIE (1880–1940), Norwegian-born painter of landscapes and seascapes. Colorfully painted bridges, New England landscapes, seascapes and city scenes dominated his oeuvre. He traveled to Panama in 1910 and recorded the last days of construction of the Canal in *The Conquerer: Panama Canal* (1913). [J0113454]

119. JACQUES LIPCHITZ (1891–1973), sculptor. A leader in his field, he was closely associated with Pablo Picasso and Juan Gris during his early career. Lipchitz' style subsequently became more expressionistic, reflecting his interest in mythological and religious subjects. [J0001875]

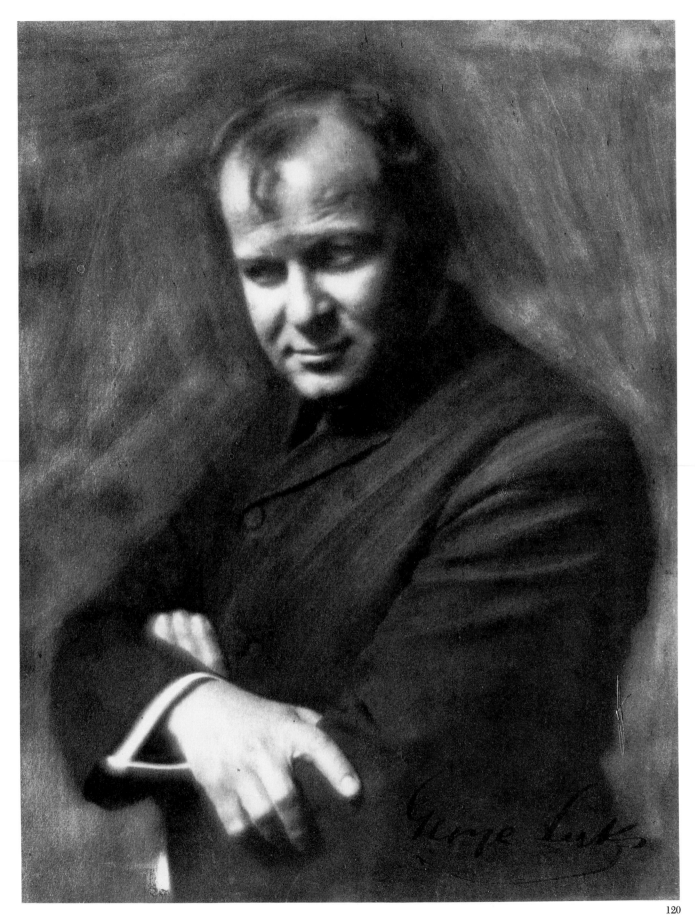

120. GEORGE LUKS (1867–1933), painter and graphic artist. As a newspaper artist in Philadelphia, Pa., he met Robert Henri, John Sloan, Everett Shinn and William Glackens. He later applied masterful, powerful brush strokes in his scenes of New York City's East Side. *Hester Street* (1905) is one of his best-known paintings. [J0001923]

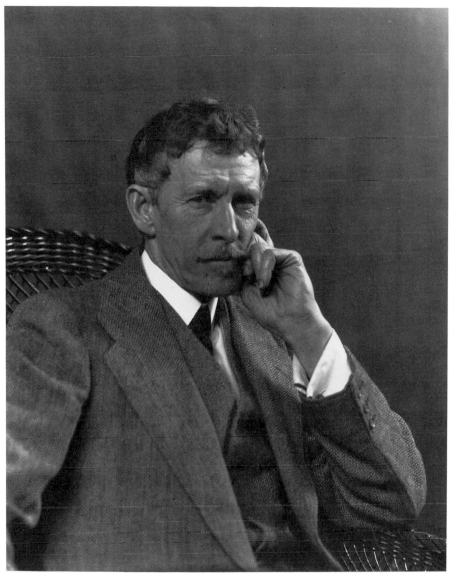

121. **FREDERICK MACMONNIES** (1863–1937), sculptor. Born in Brooklyn, N.Y., he was a skilled carver who, by the age of 18, was invited to work in Augustus Saint-Gaudens' studio. One of his numerous public commissions was *Bacchante and Infant Faun* (1893) for the Boston Public Library; the sculpture became a *cause célèbre* when citizens objected to its nudity and demanded its removal. [J0001962]

122. **PEPPINO MANGRAVITE** (1896–1978), painter, muralist, educator and author. Mangravite's paintings of still lifes, figure groups and figures in landscapes strove to symbolize universal truths. He was director of art education at the Ethical Culture School in New York City and at Sarah Lawrence College in Bronxville, N.Y. [J0003338]

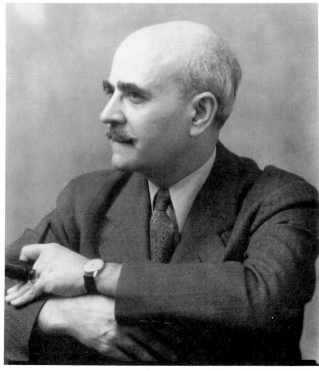

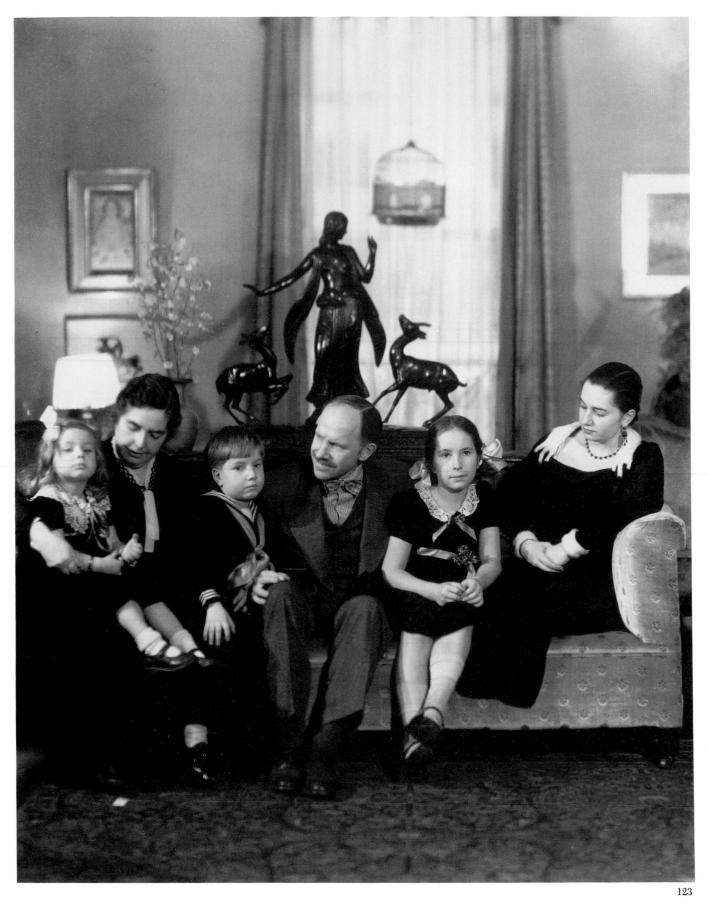

123. PAUL MANSHIP (with family; 1885–1966), sculptor. The country's most famous exponent of Art Deco, he embraced archaic vocabularies of Greek, Roman and Indian art to create decorative, stylized, Neoclassical works. The statue in the fountain in New York City's Rockefeller Plaza, *Prometheus* (1933), is one of his famous works. [J0085187]

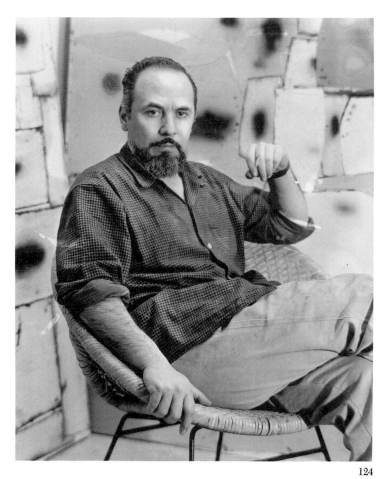

124

124. CONRAD MARCA-RELLI (born 1913), painter and collage maker, largely self-taught. The early work reflected interest in Italian Surrealism and then Abstract Expressionism. His later signature collages combine cut-out shapes of overlapping canvas, to which he adds paint. [J0001955]

125. JOSEPH MARGULIES (1896–1984), Austrian-born painter and etcher. He studied with Joseph Pennell and was committed to making his art—portraits of celebrities, scenes of New York City and New England—accessible to the layperson. [J0001947]

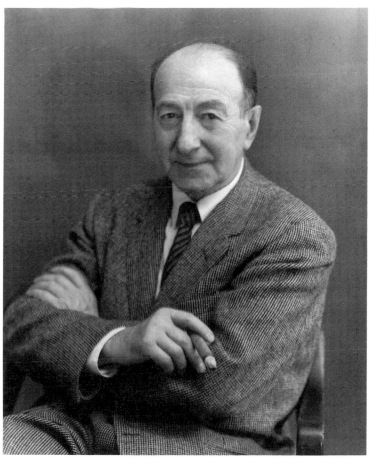

125

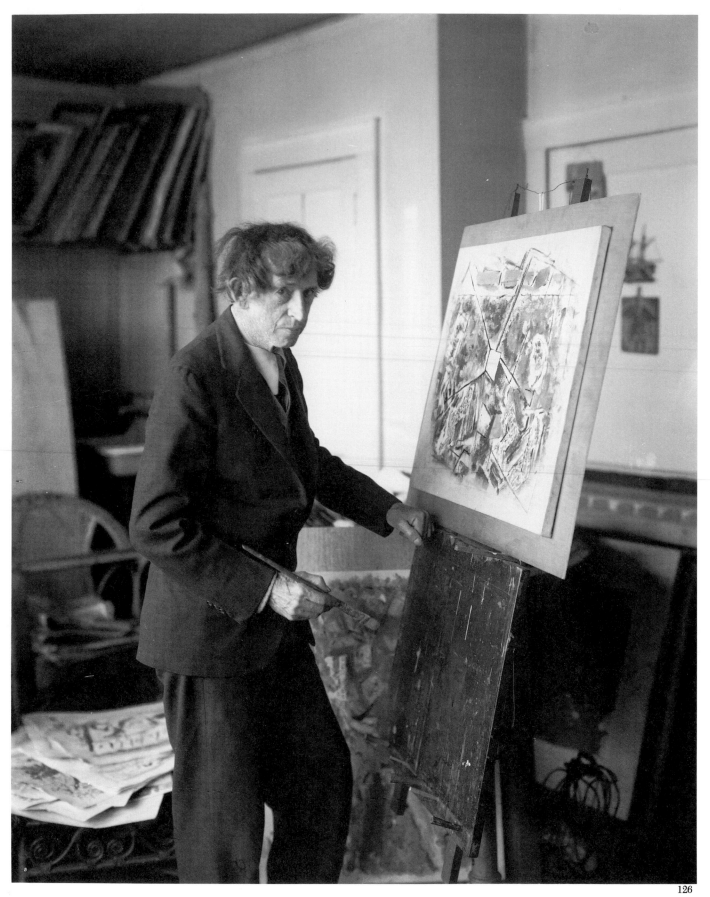

126

126. JOHN MARIN (1870–1953), painter, early modernist who worked in watercolors, oils and etching. His style was semi-abstract and expressionistic, though always rooted in natural forms and rhythms. In 1950 he became the first American to be given an exhibition at the Venice Biennale. [J0001950]

127. REGINALD MARSH (1898–1954), painter. Marsh had early experience as an artist for the *New York Daily News* and *Vanity Fair*. A second-generation Ashcan School painter, he realistically portrayed the vitality of New York City in *Why Not Use the El* (1930) and *Twenty Cent Movie* (1936). [J0001926]

128

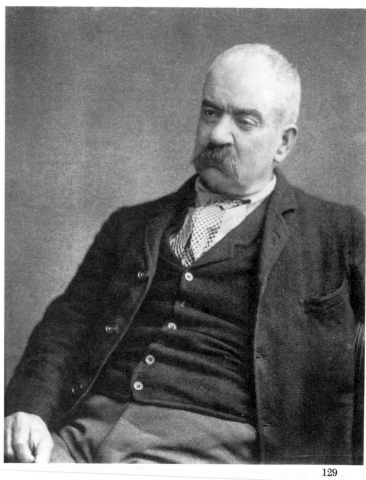

129

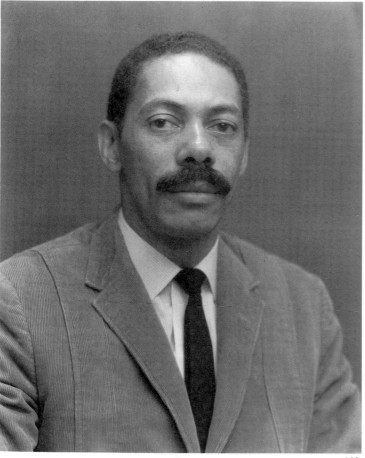

130

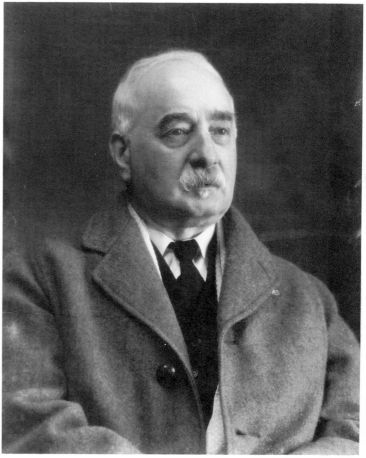

131

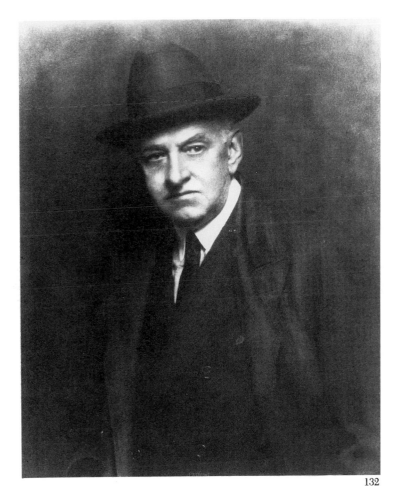

132

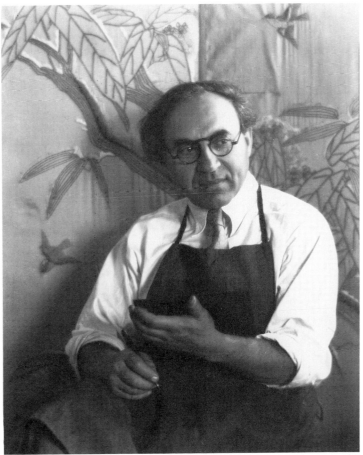

133

128. FLETCHER MARTIN (1904–1979), painter and teacher. Largely self-taught, Martin was a migratory farm worker, a lumberjack and a light heavyweight boxer in the Navy before pursuing his interest in art. He was a mural painter under the Works Project Administration and specialized in Western subjects. [J0001924]

129. HOMER DODGE MARTIN (1836–1897), painter. Martin's poetic, dreamy landscapes, painted from memory, are most closely associated with the Barbizon School. *Harp of the Winds* (1895) is a well-known work. [J0001945]

130. RICHARD MAYHEW (born 1934), painter. His abstract landscapes are informed by his experiences as an African American/Native American and his interest in the performing arts. He was a member of Spiral, a black painters' group in the 1960s in New York that included Romare Bearden, Charles Alston and Hale Woodruff as members. [J0001941]

131. J. GARI MELCHERS (1860–1932), painter. An expatriate who studied in Düsseldorf and Paris and set up a studio in Holland. He painted in an academic style that reflected the influences of Impressionism and is best known for his renderings of Dutch villagers, often in religious observance. [J0001978]

132. WILLARD METCALF (1858–1925), painter, American Impressionist whose specialty was New England landscapes, particularly in winter. He exhibited with the Impressionist group The Ten and was an important member of the art colony in Old Lyme, Conn. [J0001979]

133. WILLIAM MEYEROWITZ (1887–1981), painter and etcher. Along with his artist wife Theresa Bernstein, Meyerowitz was active in the Gloucester art community. He often depicted Jewish life on New York City's Lower East Side. [J0105690]

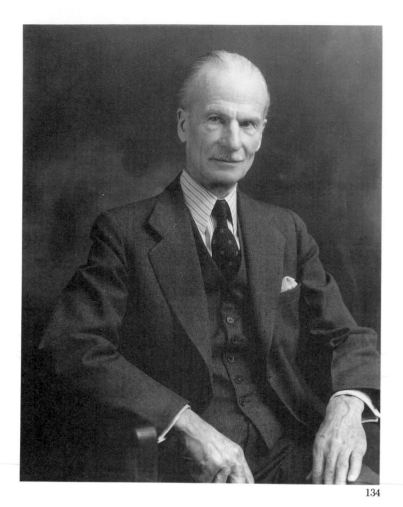

134

134. KENNETH HAYES MILLER (1876–1952), painter and teacher. An influential teacher of artistic theory and technical methods, he counted Reginald Marsh and Isabel Bishop among his students at the Art Students League. [J0001902]

135. FRANCIS LUIS MORA (1874–1940), painter and muralist. A native of Uruguay, Mora came to the United States as a child and studied at the School of the Museum of Fine Arts, Boston, under Frank Benson and Edmund Tarbell. His mural commissions included the Orpheum Theatre in Los Angeles and the Red Cross Headquarters in Washington, D.C. [J0096220]

135

136

136. THOMAS MORAN (1837–1926), landscape painter. Influenced by J. M. W. Turner, Moran is best remembered for his idealized views of the American West. In 1871 he accompanied a government surveying expedition to Yellowstone and was greatly inspired by the landscape; *The Grand Canyon of the Yellowstone* (1893–1901) and *The Chasm of the Colorado* (1872) are two outstanding works. [J0001991]

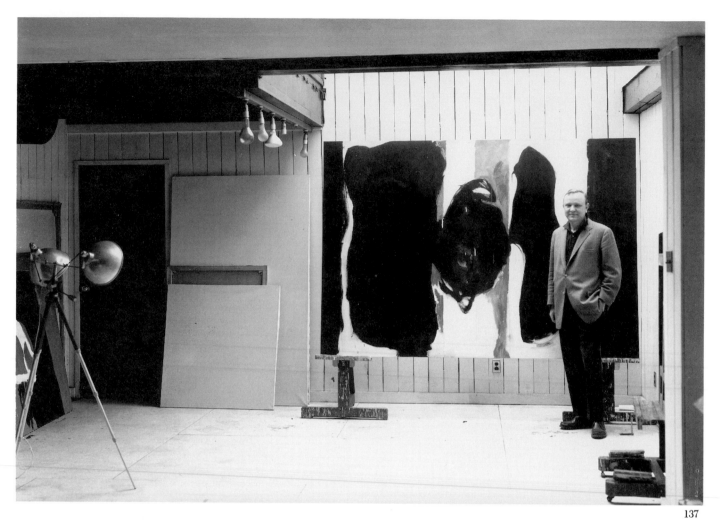

137

138

137. ROBERT MOTHERWELL (1915–1991), painter, printer, collage maker and author. A leading Abstract Expressionist, in 1949 he began his most famous series, *Elegies to the Spanish Republic*, which is comprised of more than 100 oil paintings and numerous sketches and drawings. He was editor of the important book series *Documents of Modern Art*. [J0004864]

138. J. FRANCIS MURPHY (1853–1921), landscape painter, largely self-taught. Born in Oswego, N.Y., he made the native countryside his subject matter. His early work was Barbizon influenced; the later, more popular, work was tonalist in style. His reputation declined considerably in the 1930s and 1940s. [J0001908]

139

140

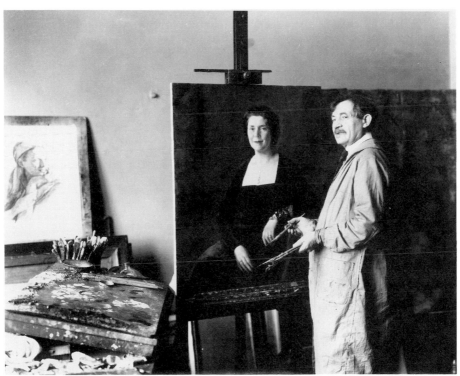

141

139. JEROME MYERS (1867–1940), painter. Sentimental depictions of the urban landscape dominate his oeuvre. *Artist in Manhattan* (1940), his autobiography, was published shortly before his death. [J0001922]

140. REUBEN NAKIAN (1897–1986), sculptor. Nakian reevaluated his early style, influenced by Gaston Lachaise and William Zorach, after meeting Arshile Gorky and Stuart Davis. His mature style, often expressed in monumental works, was analogous to Abstract Expressionist painting—with highly textured surfaces, improvisational gesture and broad pictorial interpretation. [J0121383]

141. IVAN G. OLINSKY (1878–1962), painter and teacher. Olinsky studied with J. Alden Weir, George W. Maynard and Robert Vonnoh at the National Academy of Design in New York. His figure paintings, academic in style and influenced to a degree by Impressionism, were shown frequently at the Macbeth Gallery and Grand Central Galleries in New York City. [J0002025]

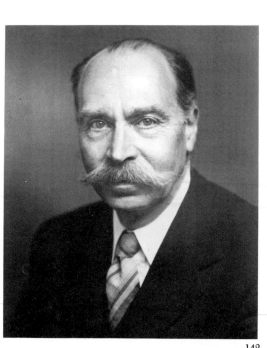

142

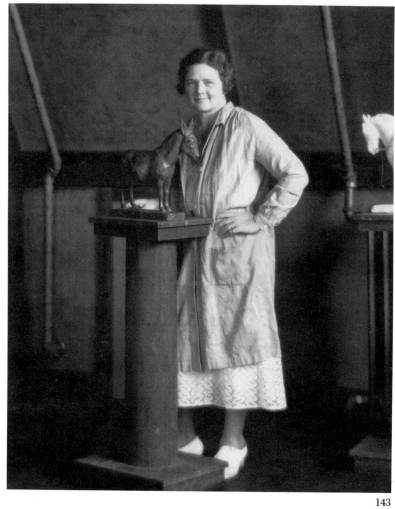

143

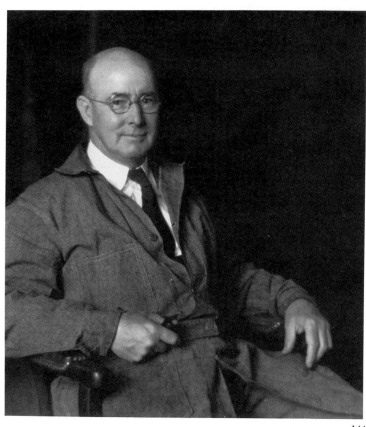

144

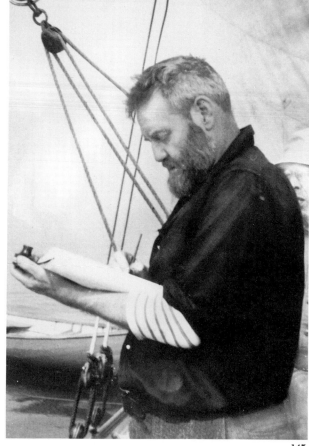

145

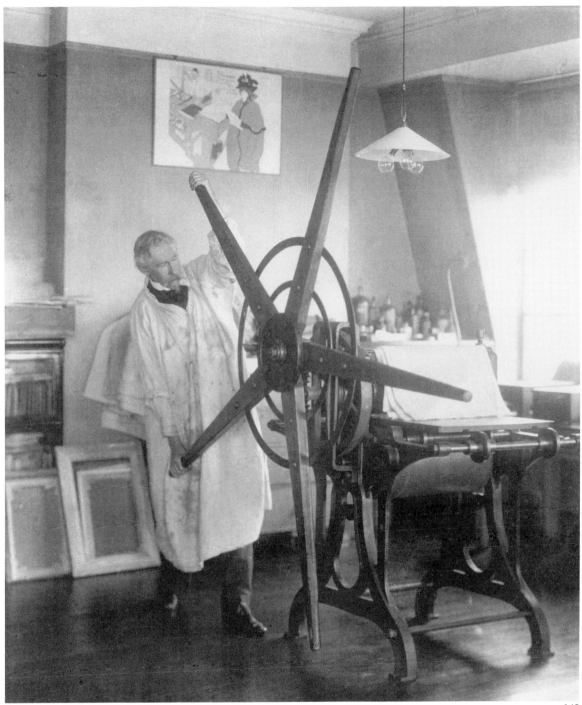

146

142. WALTER PACH (1883–1958), artist, critic, teacher. Influenced by Henri Matisse, Jacques Villon, Pablo Picasso and Paul Cézanne, he worked in both oil and watercolor and did etchings. He published 11 books, translated Elie Faure's five-volume *History of Art* and helped to organize the famous Armory Show of 1913. [J0002035]

143. MADELEINE PARK (1891–1960), animal sculptor. A childhood interest in carving soap animals evolved into Park's career in sculpture. Working from living models, she studied at zoos, circuses and African national parks. Park sculpted a wide range of wild animals, including a pygmy elephant, lion, gnu, polar bear, aoudad and tiger. She modeled in bronze, stone and ceramics. [J0017141]

144. WILLIAM PAXTON (1869–1941), painter. Paxton painted the leisured class. Considered old-fashioned by some modernists, he was a prominent genre and portrait painter in the Beaux Arts style. [J0002037]

145. WALDO PEIRCE (1884–1970), painter. Harvard graduate and onetime companion of author Ernest Hemingway, Peirce was a larger-than-life, bon vivant adventurer whose art is integrally linked with his life experiences. He created joyful, realistic paintings of family life in his home state of Maine. [J0002063]

146. JOSEPH PENNELL (1857–1926), printmaker and illustrator. Pennell lived abroad for many years and depicted European scenes in a number of his prints. He illustrated approximately 100 books and was influenced in style by James Abbott McNeill Whistler. [J0002045]

147

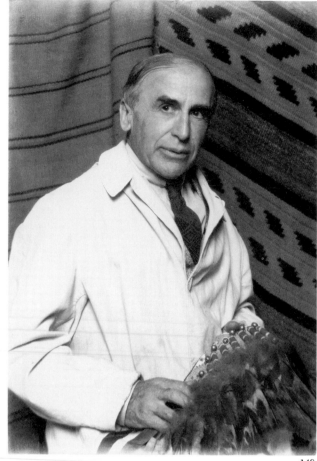

148

149

147. **ROBERT PHILIPP** (1895–1981), painter and teacher. He received his training in New York at the National Academy of Design and the Art Students League. Female portrait studies and café scenes dominate his work. [J0002057]

148. **BERT GEER PHILLIPS** (1868–1956), painter. Born near Albany, N.Y., and educated in New York and Paris, Phillips traveled in 1898 with fellow artist Ernest Blumenschein to Taos, N.M., where they founded the Taos Society of Artists. Phillips remained there and dedicated his efforts to the poetic depiction of Native Americans. [J0040490]

149. **ATTILIO PICCIRILLI** (1866–1945), sculptor. He was the eldest and most noted artist among six brothers who emigrated from Italy and established a studio in New York. The *Maine Monument* (1901–13) at the entrance to Central Park and the *Fireman's Memorial* (ca. 1912) on Riverside Drive in New York City are two notable sculptures. [J0041644]

150. OGDEN PLEISSNER (1905–1983), Brooklyn-born painter specializing in watercolor. He was an official war artist during World War II and later won many awards for his landscapes of New England, Wyoming and Nova Scotia. [J0002069]

151. WILLIAM POGANY (1882–1955), Hungarian illustrator. He completed more than 150 books and designed stage productions for both the Metropolitan Opera and the Ziegfeld Follies. Later, he worked as art director for film mogul Samuel Goldwyn. [J0002070]

152. LARRY POONS (born 1937), painter who established himself as an Op artist with his first one-man show in 1963. By the late 1960s, he began introducing Abstract Expressionist elements into his work. [J0002067]

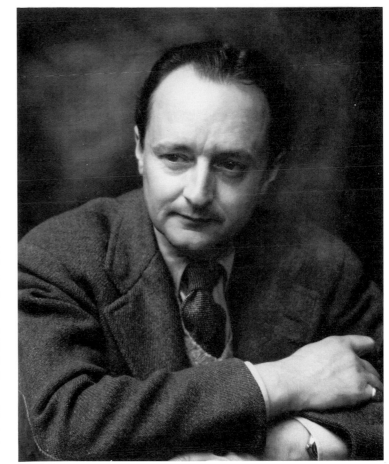

150

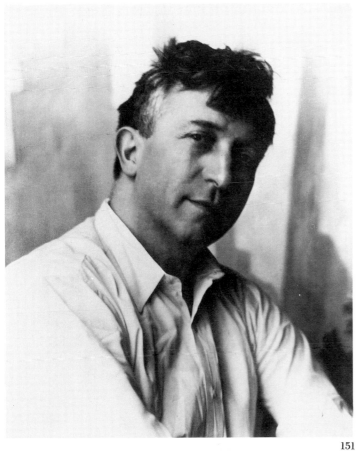

151

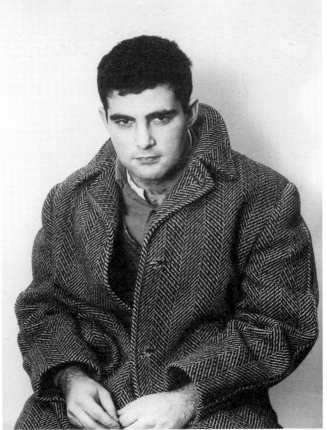

152

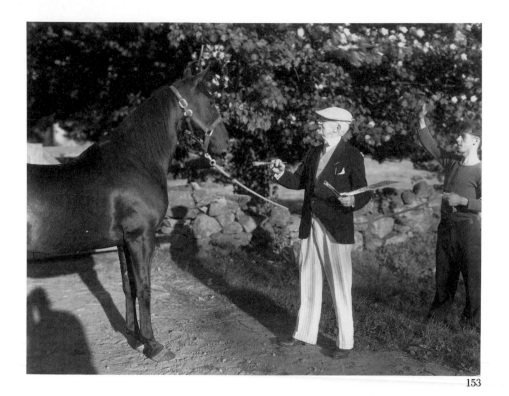

153

153. **HENRY RANKIN POORE** (1859–1940), painter and author who began painting landscapes, but eventually peppered his landscapes with animals. A founder of the summer art colony at Old Lyme, Conn., he wrote *Pictorial Composition and the Critical Judgment of Pictures* (1903). [J0110049]

154. **HOWARD PYLE** (1853–1911), illustrator, writer and teacher. During his prolific career, he produced 3,300 illustrations, many for his own articles and books. He taught at Drexel Institute and trained many important illustrators, including Frank Schoonover, Jessie Wilcox Smith and N. C. Wyeth. [J0002086]

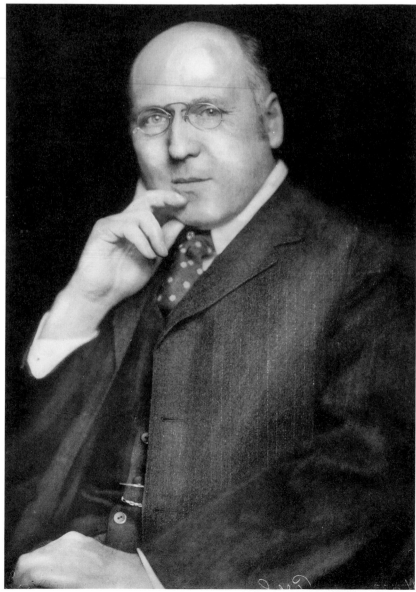

154

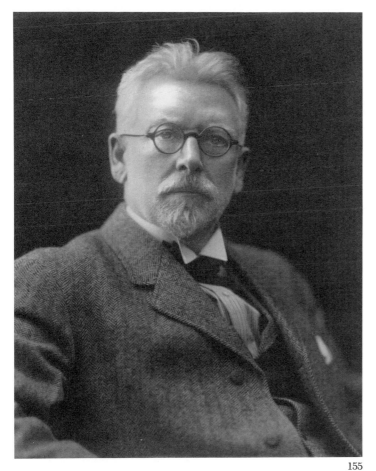

155. **HENRY WARD RANGER** (1858–1916), landscape painter. Influenced by the Barbizon School, he founded the American Barbizon School in Old Lyme, Conn. Upon his death, he left much of his estate to the National Academy of Design for the purchase of works by emerging artists. [J0002098]

156. **ABRAHAM RATTNER** (1895–1978), painter whose influences included Cubism, the work of Georges Rouault and Pablo Picasso, Romanesque art, Byzantine mosaics and Greek Orthodox icons. His subjects ranged from religious themes to landscapes, each one imbued with spiritual and psychological overtones. [J0002095]

157. **EDWARD WILLIS REDFIELD** (1869–1965), landscape painter who lived in Pennsylvania. Redfield was the leader of a group of artists that included Daniel Garber, Walter Schofield and Robert Spencer. Winter scenes were his forte. [J0051240]

155

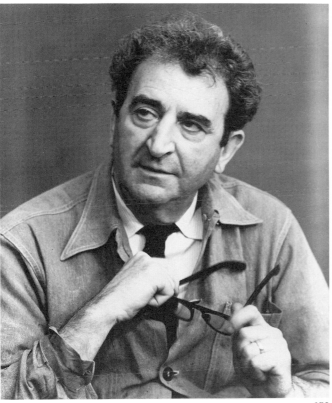

156

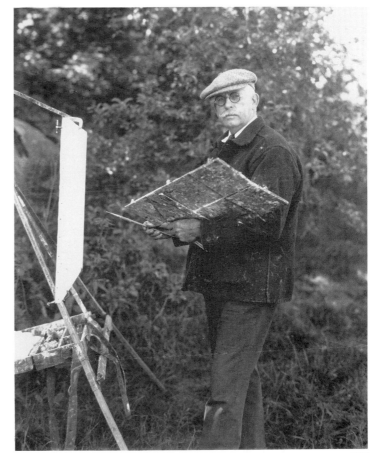

157

71

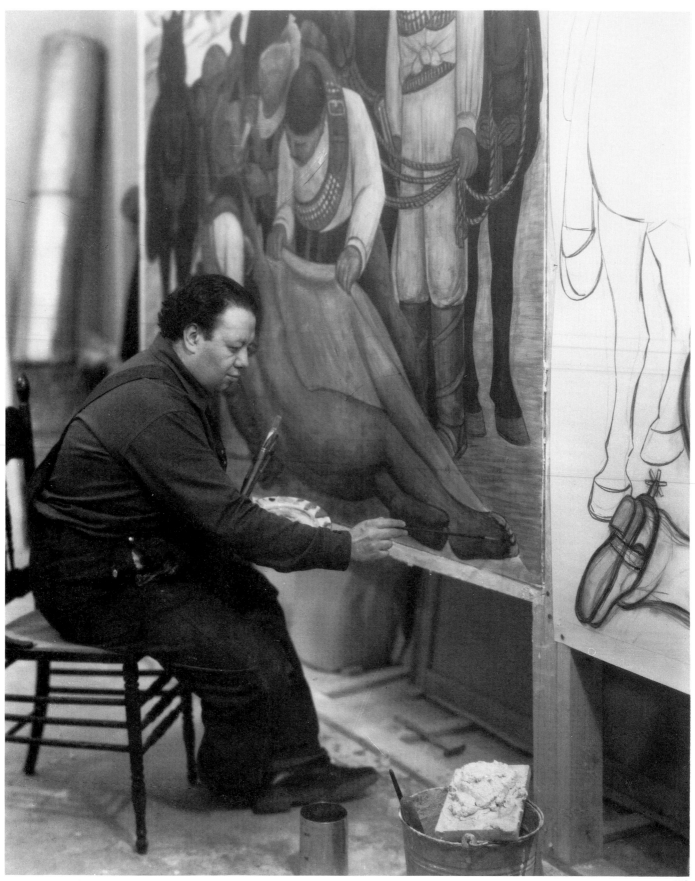

158. DIEGO RIVERA (1886–1957), painter and muralist, husband of Frida Kahlo. His memorable commissions in Mexico—such as the Ministry of Public Education (Mexico City), Cortés Palace (Cuernavaca, Morelos) and the National Agricultural School (Chapingo, Mexico City)—are both historical and allegorical. In the United States, his murals at the Detroit Institute of Arts are also noteworthy. Although some of his work is currently labeled propagandistic because it reflects his embrace of Communism, he is still considered one of Latin America's leading artists. [J0033262]

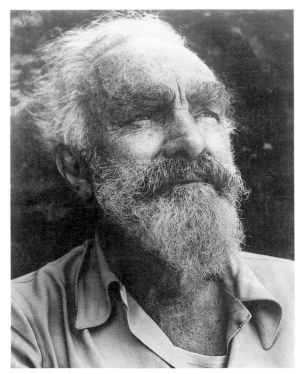

159

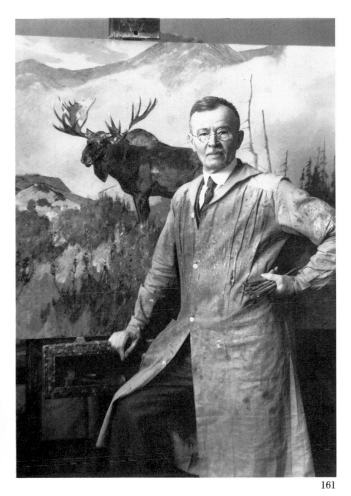

161

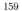

160

159. BOARDMAN ROBINSON (1876–1952), cartoonist and illustrator. The incisive political cartoons he contributed to the *New York Tribune, Metropolitan Magazine, Harper's Weekly,* the *Outlook* and the *Masses,* as well as his illustrations for John Reed's *The War in Eastern Europe,* inspired many young artists. [J0002117]

160. NORMAN ROCKWELL (1894–1978), illustrator. A prolific artist, Rockwell created more than 300 covers for *The Saturday Evening Post* in addition to illustrating calendars, books, posters and advertisements. His work immortalized American family values and homespun characters. *Four Freedoms* (1943), a series of illustrations he created for the World War II effort, is the best known. [J0002116]

161. CARL RUNGIUS (1869–1959), German-born painter. Rungius was a committed outdoorsman. With an eye to anatomical accuracy, he painted big game in the American West. [J0002135]

162

162. ALBERT PINKHAM RYDER (1847–1917), painter. Themes of nature, literature and religion dominate his visionary, romantic and highly imaginative paintings. *The Race Track (Death on a Pale Horse)* ca. 1880s–1890s, is a significant work. [J0002132]

163. CHAUNCEY FOSTER RYDER (1868–1949), landscape painter, etcher, lithographer. Ryder studied at the Art Students League in New York and at the Académie Julian in Paris. He was honored as an Academician of the National Academy of Design in 1914. [J0002123]

164. AUGUSTUS SAINT-GAUDENS (1848–1907), sculptor who combined naturalism and monumentality in his sculpture and was one of the best-known and influential sculptors of his day. Powerful in its restraint, his most distinctive piece, the *Adams Memorial* (1886–91), is a seated, draped, brooding figure. [J0021712]

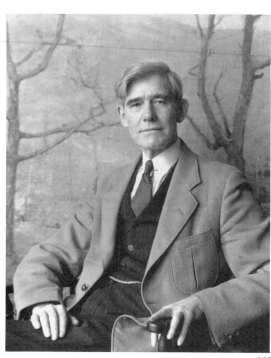

163

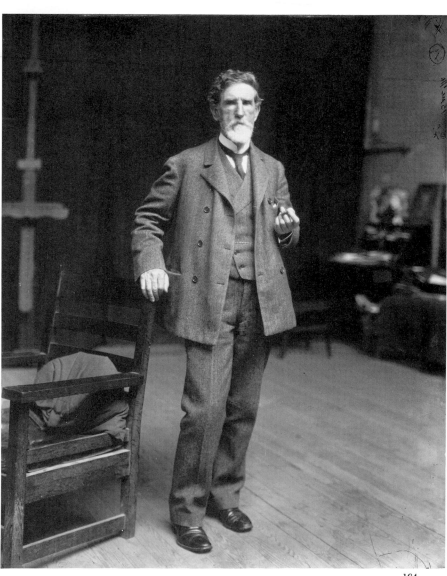

164

165

165. HÉLÈNE SARDEAU (1899–1969), Belgian-born sculptor. Sardeau studied in the United States with Mahonri Young and exhibited internationally. Contemplation, serenity and humanism were often conveyed in her work. Her first major commission, *Slave* (1933), a six-foot depiction in limestone of a manacled African American, was executed for a sculpture garden in Fairmount Park, Philadelphia. She was the wife of painter George Biddle. [J0066480]

166. JOHN SINGER SARGENT (1856–1925), painter. Sargent traveled in a circle of socially prominent people and is known for his loosely painted portraits done in a style reminiscent of Edgar Degas and James Abbott McNeill Whistler. *Madame X* caused a minor scandal at the Salon of 1884 and was rejected by Sargent's client because Sargent depicted her as vain. He devoted his later career to impressionistic watercolor scenes. [J0002143]

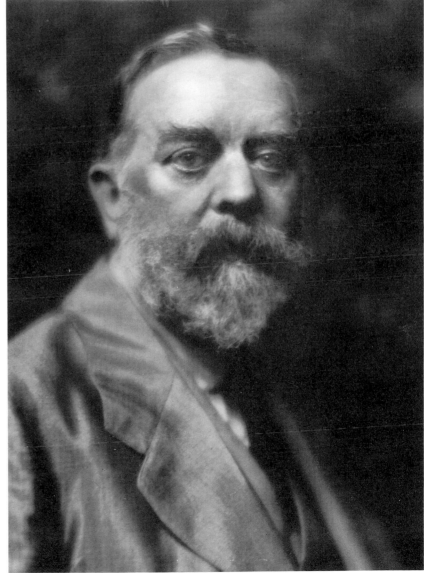

166

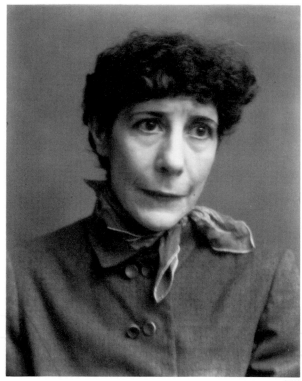

167

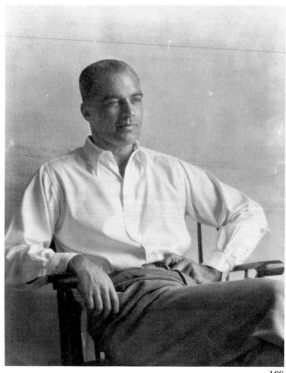

168

167. CONCETTA SCARVAGLIONE (1900–1975), sculptor and teacher. She worked in terra-cotta, wood, welded copper and bronze and was awarded the Prix de Rome in 1947. She taught at New York University, Black Mountain College, Sarah Lawrence College, the Educational Alliance and Vassar College. [J0002149]

168. HENRY SCHNAKENBERG (1892–1970), painter. He was a realist known for his renderings of New York's Central Park and other bucolic cityscapes. The tone of his paintings is detached and understated. [J0002158]

169. BEN SHAHN (1898–1969), painter, printmaker and photographer. Social and political activism were essential elements of his work. In a simple, abstracted style, he treated themes such as the Sacco-Vanzetti trial (1931–32), the Tom Mooney trial (1932–33) and the Dreyfus Affair (1930). His philosophy of art was published in a widely read volume, *The Shape of Content* (1957). [J0002173]

169

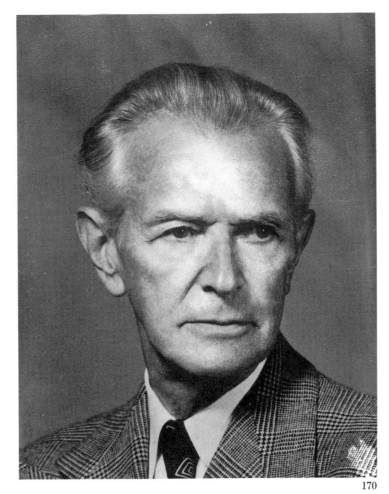

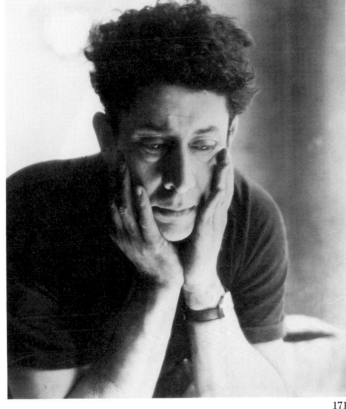

171

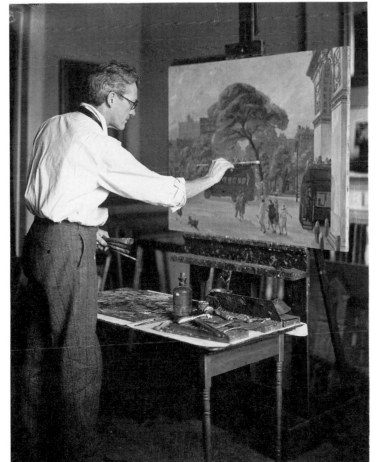

172

170. EVERETT SHINN (1876–1953), painter, illustrator and decorator. A member of The Eight, Shinn created a significant body of work in murals for private homes as well as for theaters; he often depicted life in the slums, café society and theater events. [J0002178]

171. DAVID ALFARO SIQUEIROS (1896–1974), painter and muralist. One of the "Big Three" Mexican muralists (the others being José Orozco and Diego Rivera), he created proletarian art that was inseparable from his activist politics. Siqueiros was a technical innovator; he used film projectors, airbrushes and spray guns to carry out his theories of "dynamic realism" and "kinetic perspective." [J0070440]

172. JOHN SLOAN (1871–1951), painter, illustrator and teacher. With William Glackens, George Luks, Robert Henri and Everett Shinn, Sloan was part of the Ashcan School. His sympathetic, but unsentimental, depictions of urban life and the working class expressed his commitment to social reform. [J0002183]

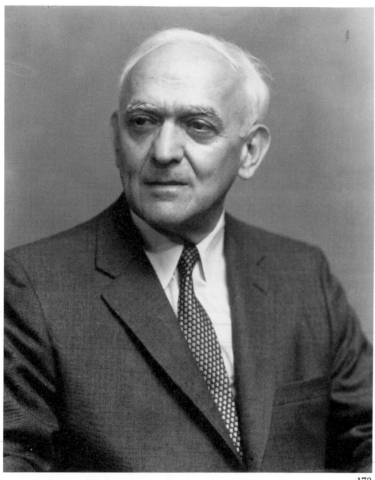

173

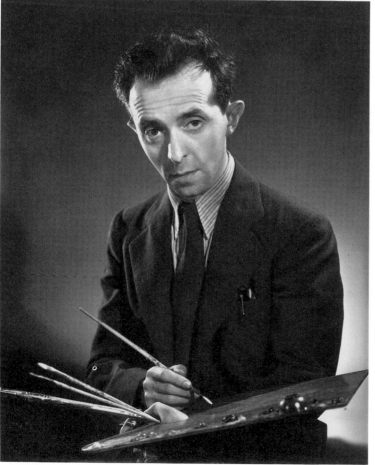

174

173. ISAAC SOYER (1902–1981), painter, trained at Cooper Union. The younger brother of artists Raphael Soyer and Moses Soyer, he often portrayed working-class people in New York City. [J0115186]

174. RAPHAEL SOYER (1899–1987), painter and printmaker, a twin brother of artist Moses Soyer. His sympathetic and melancholic paintings expressed the aspirations and disappointments of ordinary people. He frequently painted himself and other artists, *Homage to Thomas Eakins* (1964–65) being one such work. [J0111203]

175. EUGENE SPEICHER (1883–1962), painter. Born in Buffalo, N.Y., where he also studied with Frank DuMond and William Merritt Chase. Despite his early associations with modern American realism, he executed his portraits, figure paintings of girls and women, floral still lifes and nudes in a traditional academic style. [J0093277]

176. THEODOROS STAMOS (born 1922), painter, a first-generation Abstract Expressionist who mounted a one-man show at the age of 21. Biomorphic forms, with a resemblance to the work of Mark Rothko and William Baziotes, inhabited his early canvases. More recently, Stamos has committed further to abstraction by activating his brushstroke and by modulating the tonalities of his paintings. [J0002202]

177. MAURICE STERNE (1878–1957), painter and sculptor. He traveled extensively and drew upon his voyages for inspiration; paintings of life in Bali were particularly well received. In 1933, he had a retrospective at The Museum of Modern Art in New York City, the first American so honored. [J0099136]

178. ALBERT STERNER (1863–1946), painter, printmaker and illustrator. While serving on staff positions at *Century Magazine*, *Harper's* and *Life*, Sterner gained critical recognition for his skillful and fluid draftsmanship. He also specialized in portraits of famous patrons such as the Vanderbilts, Whitneys and Wideners. [J0002208]

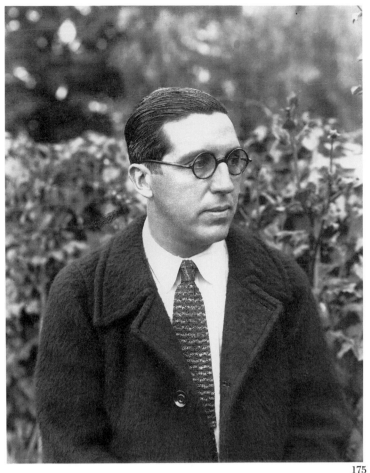

175

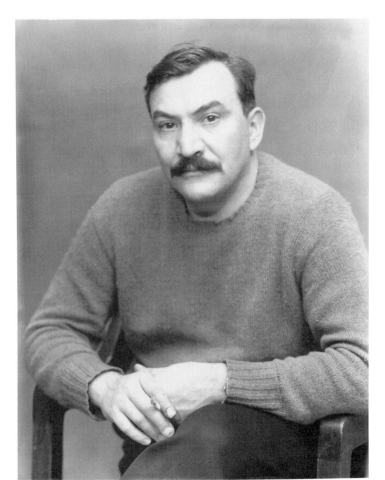

176

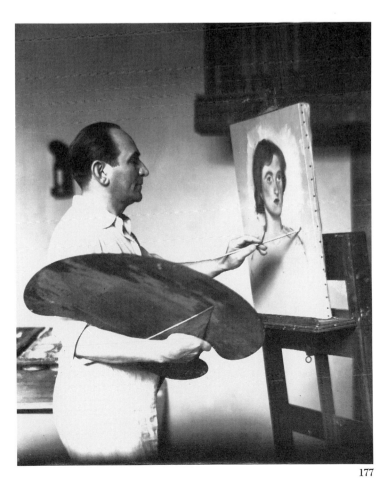

177

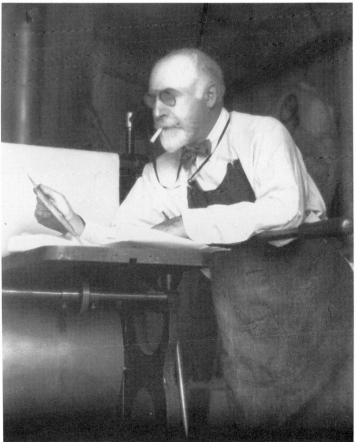

178

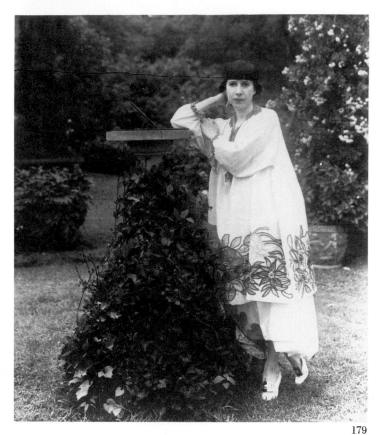

179. FLORINE STETTHEIMER (1871–1948), painter and theater designer. With her sisters and mother, Stettheimer presided over a salon of New York City artists, attracting such modernists as Marcel Duchamp and Elie Nadelman; she immortalized her salon in the group portrait *La Fête à Duchamp* (1917). Her very personal artwork was a combination of the symbolic, fantastic, naive and primitive. [J0118518]

180. RUFINO TAMAYO (1899–1991), Mexican painter and muralist, who was influenced by the European modernism of Henri Matisse, Georges Braque and Pablo Picasso as well as pre-Columbian art and Mexican folk art. He rejected the dogma of the muralist explosion after the Mexican Revolution in favor of an exploration of modernist styles, waiting until 1933 to paint his first mural. [J0048185]

179

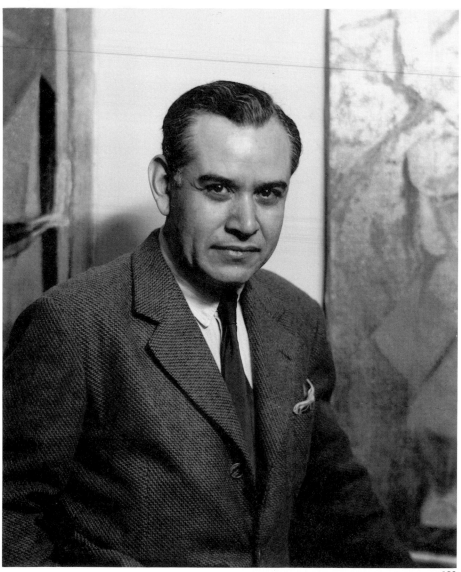

180

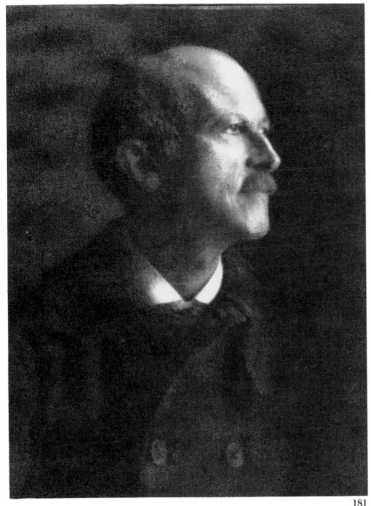

181

182

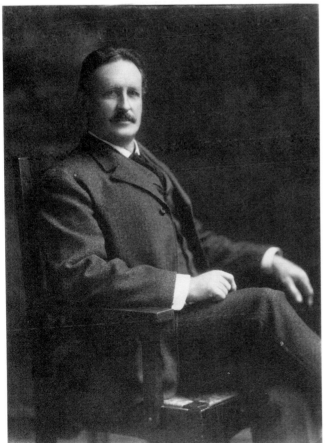

183

181. ABBOTT HANDERSON THAYER (1849–1921), painter, best known for his idealistic and allegorical paintings of women as angels and madonnas. His interest in color and nature led to his writing *Concealing Coloration in the Animal Kingdom* (1909), the basis for camouflage techniques in World War I. [J0002236]

182. GEORGE TOOKER (born 1920), painter. He studied with Reginald Marsh and Kenneth Hayes Miller at the Art Students League and later with Paul Cadmus. To achieve his haunting scenes of urban isolation and modern-day mechanization, Tooker employs the Renaissance egg-tempera technique. [J0002235]

183. DWIGHT WILLIAM TRYON (1849–1925), painter and teacher. A tonalist, Tryon painted landscapes and seascapes in which his subtle manipulation of atmosphere and mood were key elements. Charles Lang Freer was his avid patron and many of Tryon's paintings are in the Freer Gallery of Art in Washington, D.C. [J0103733]

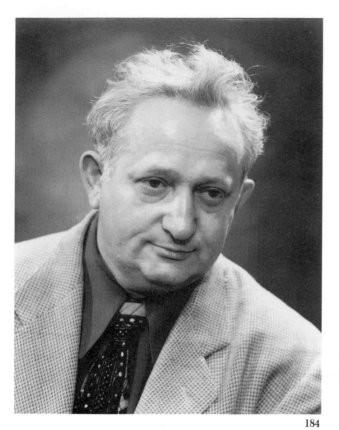

184. NAHUM TSCHACBASOV (1899–1984), painter, graphic artist. Originally an accountant and efficiency expert, Tschacbasov turned to painting in 1930 and specialized in encaustic. His style was expressionistic and colorful with subjects ranging from the social conditions of his day to animals rendered in a whimsical, fantastic style. [J0036564]

185. JOHN TWACHTMAN (1853–1902), painter, founding member of The Ten. He studied with Frank Duveneck, and his early canvases reflected the influence of the Munich Academy. The mature work showed a concern for light and subtle tonalities, expressed in poetic and monochromatic evocations of the landscape. [J0002240]

184

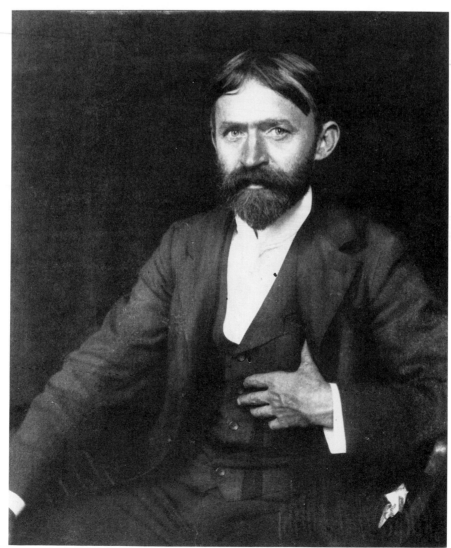

185

186. ABRAHAM WALKOWITZ (1880–1965), painter. A Russian-born modernist, Walkowitz exhibited at the Little Galleries of the Photo-Secession, the 1913 New York Armory Show and the 1916 Forum Exhibition. He made thousands of drawings of one subject—modern dancer Isadora Duncan. Walkowitz also took an active part in starting the People's Art Guild, the first American artists' cooperative. [J0002257]

187. FREDERICK JUDD WAUGH (1861–1940), marine painter. Waugh's sea paintings were enthusiastically received; for five consecutive years, he was awarded the Popular Prize at the Carnegie International Exhibition. [J0073006]

188. MAX WEBER (1881–1961), painter, sculptor, poet. Weber was an adventurous modernist who assimilated the influences of Cubism, Futurism, Orphism and Postimpressionism. Weber later memorialized his Jewish heritage in such works as *Students of the Torah* (1940) and *Adoration of the Moon* (1944). [J0073357]

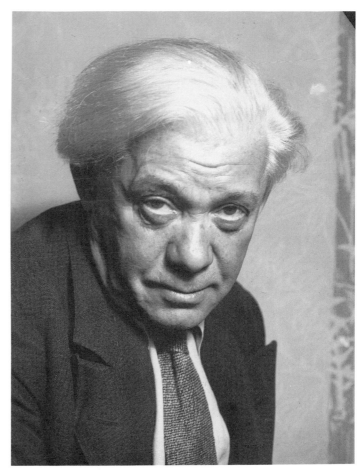

186

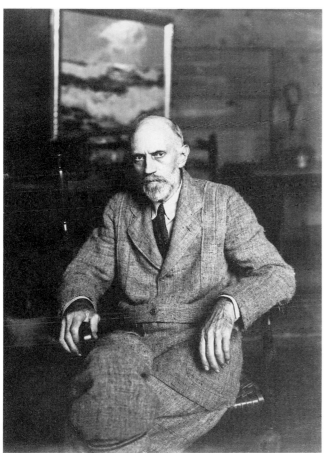

187

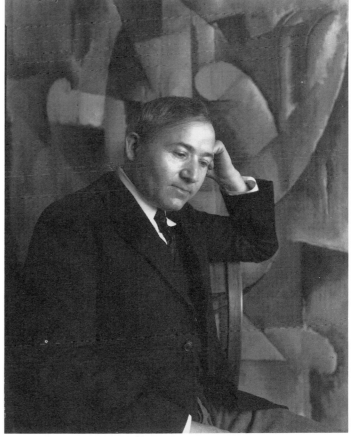

188

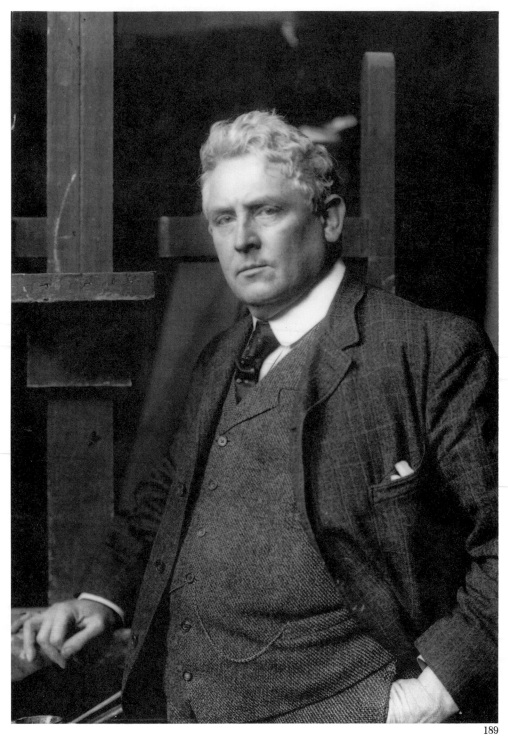

189

189. JULIAN ALDEN WEIR (1852–1919), painter. As a leading American Impressionist, an important member of The Ten, president of the National Academy of Design and adviser to several major American collectors, Weir was an influential presence in the art world. *The Red Bridge* (1895) is his most famous work. [J0073524]

190. STOW WENGENROTH (1906–1978), lithographer. Although he was born in New York City, Wengenroth devoted himself to depictions of the harbors, buildings, flora and fauna of New England. A master of lithography, he won more than 30 print prizes and later published *Making a Lithograph.* [J0002278]

191. JOHN WHORF (1903–1959), watercolor painter. Native of Massachusetts and descendant of Cape Cod sea captains, Whorf's specialty was marine subjects. [J0002274]

192. GUY WIGGINS (1883–1962), painter, American Impressionist. Winter scenes of upstate New York and New England dominated his work. He eclipsed the fame of his father, Carleton, who was also a landscape painter and his first teacher. [J0047700]

193. WHEELER WILLIAMS (1897–1972), sculptor, a founder and president of the American Artist Professional League. He studied sculpture at the Art Institute of Chicago and architecture at Harvard; portrait, garden and animal sculpture dominated his work. [J0002287]

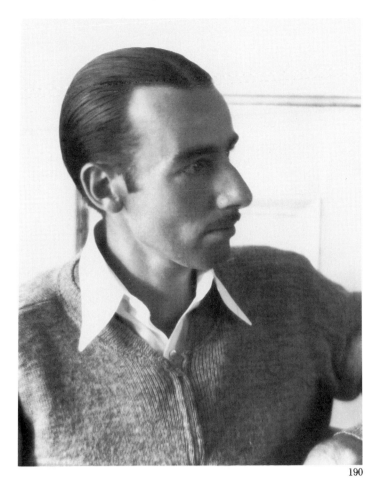

190

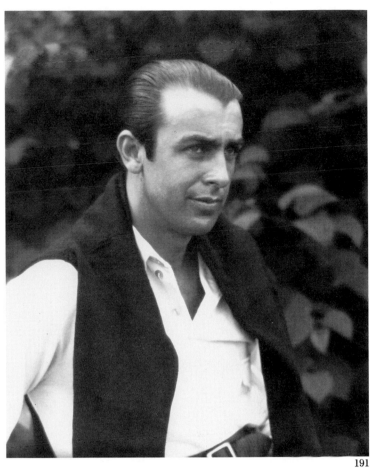

191

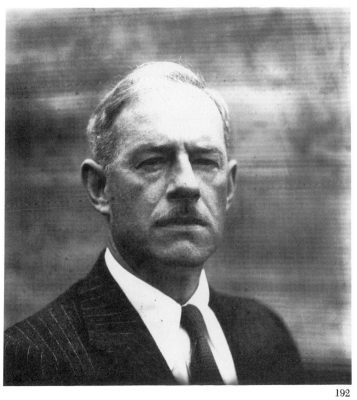

192

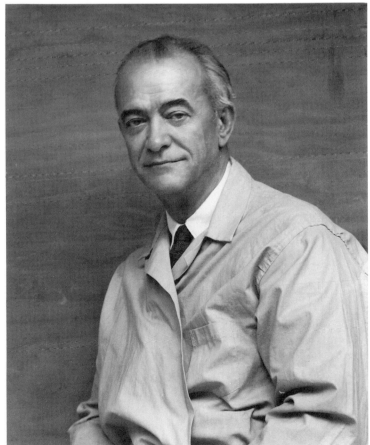

193

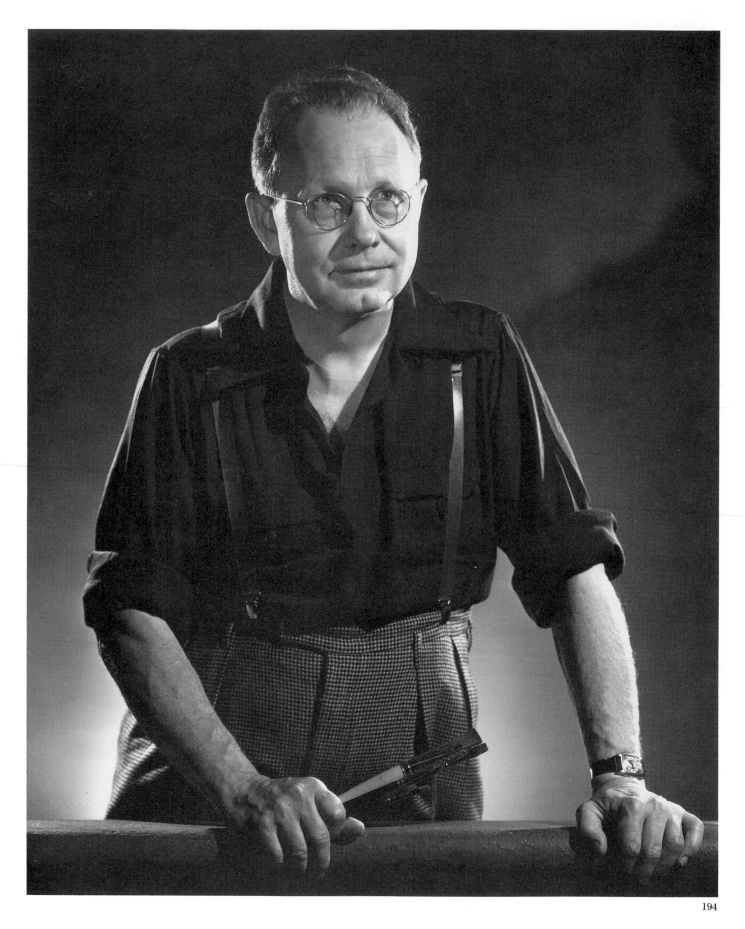

194. GRANT WOOD (1892–1942), painter. A practitioner of American scene painting, Wood painted views of the Midwest in a realistic style mixed with satire. His most famous work, *American Gothic* (1930), is an American icon. [J0002303]

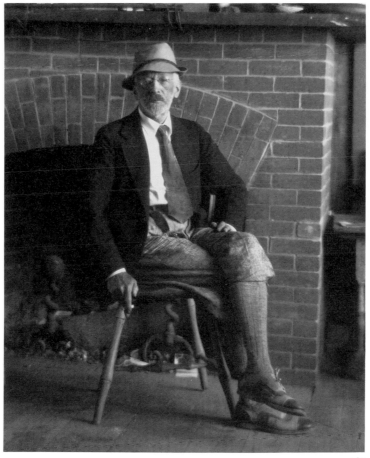

195

195. CHARLES WOODBURY (1864–1940), painter and etcher specializing in interpretations of the sea and mountains. He taught at the Ogunquit Artists Colony in Maine and synthesized his ideas into two books—*Painting and the Personal Equation* (1923) and *The Art of Seeing* (1925), which he coauthored with Elizabeth Ward Perkins. [J0122229]

196. ALEXANDER WYANT (1836–1892), landscape painter in the style of George Inness. His early paintings followed closely the Hudson River tradition, while the later—infused with low-key colors, atmospheric features and poetic interpretation—are representative of tonalism. [J0002310]

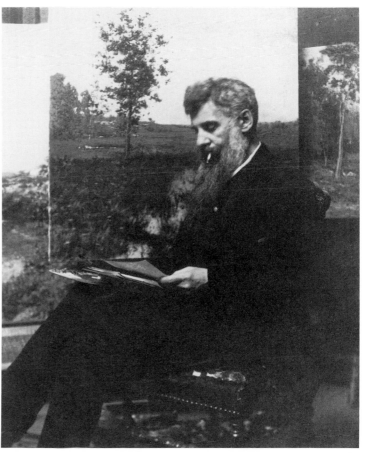

196

197. MAHONRI MACKINTOSH YOUNG (1877–1957), sculptor. Young was a native of Salt Lake City, Utah, and a grandson of the Mormon leader Brigham Young. He realistically sculpted working men, prizefighters and Native Americans and was founder of the American Water Color Society. [J0002312]

198. OSSIP ZADKINE (1890–1967), sculptor and teacher. Although he was born in Russia, Zadkine lived and taught primarily in France. He was an important Cubist sculptor whose post-1920s work became more lyrical and expressive. [J0002318]

199. MARGUERITE THOMPSON ZORACH (1887–1968), painter, weaver, graphic artist. Along with her husband, sculptor William Zorach, she was an innovator in the modernist movement in the United States. With her many embroidered tapestries, she distinguished herself as an outstanding designer. [J0029484]

197

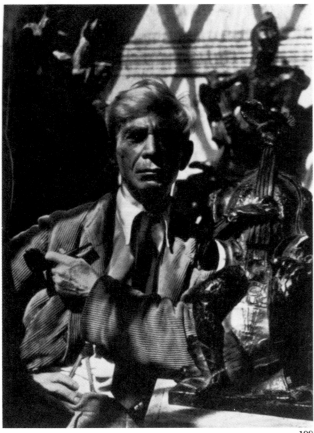

198

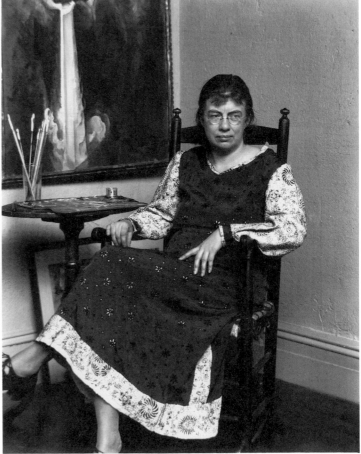

199

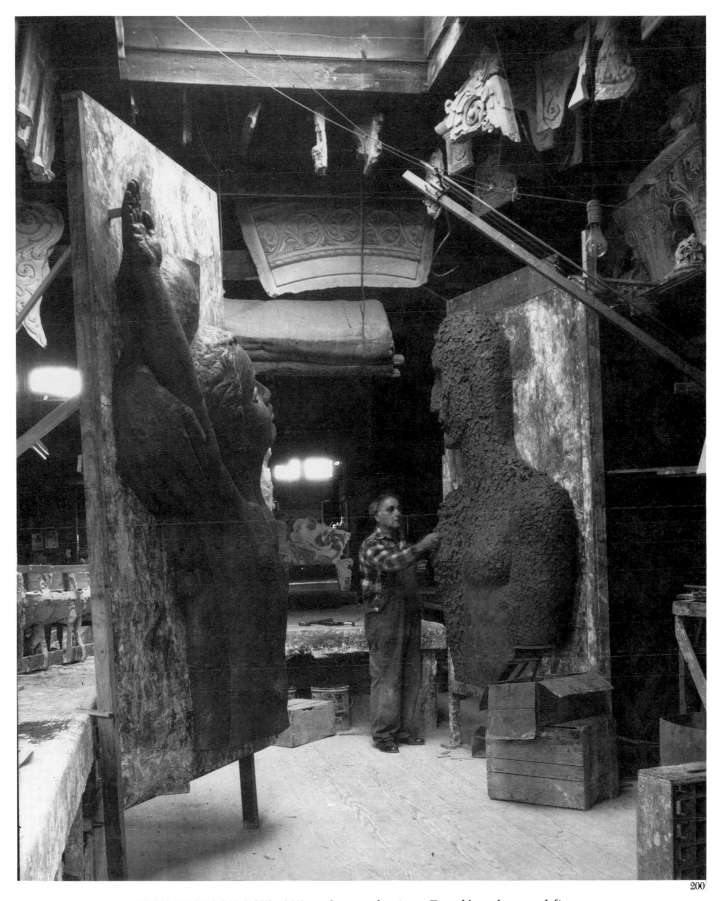

200. WILLIAM ZORACH (1887–1966), sculptor and painter. Zorach's early carved figures were Cubist in style, but his mature style, responsive to primitive and archaic art, was represented by rounded, simplified, monumental forms. Mothers and their children were a dominant theme throughout his career. [J0029619]